The College History Series

DELAWARE STATE UNIVERSITY

BRADLEY SKELCHER

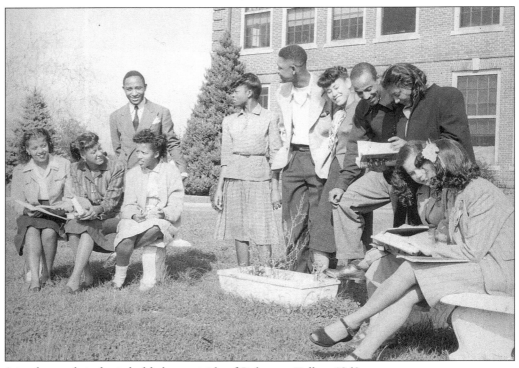

A teacher and students hold class outside of Delaware Hall, *c.* 1940s.

Hurrah! for State College She is climbing in the rank.
She is raising, broadening, and strengthening her bank.
Ten graduates from here this year will go,
State College is proud of this you know.
As years roll by State College is raising,
Her progress honorable men are praising.
We hope some day she can raise her sail,
go out in world and cope with Yale.
The History of the school yearly tells,
But ne'er a year has she done so well,
Eight and two graduates will leave this year
hoping good tiding from them to hear.
The ones that have gone are waiting to hear,
The progress of the school this present year,
When they hear it they will hardly believe,
That ten graduates are about to leave.
Hurrah! for the anthem the choir gently sings,
Its melody to the earth to heaven does ring.
To the graduates its singing for heading to roam.
They are sweetly singing bring the pilgrims home.
—"College Song" by Solomon Gibbs, *c.* early 1900s
(Courtesy of Lucretia Wilson and Star Hill AME Church.)

The College History Series

DELAWARE STATE UNIVERSITY

BRADLEY SKELCHER

ARCADIA

Published by Arcadia Publishing,
an imprint of Tempus Publishing, Inc.
2 Cumberland Street
Charleston, SC 29401

Printed in Great Britain.

Library of Congress Catalog Card Number: 00-105293

For all general information contact Arcadia Publishing at:
Telephone 843-853-2070
Fax 843-853-0044
E-Mail sales@arcadiapublishing.com

For customer service and orders:
Toll-Free 1-888-313-2665

Visit us on the internet at http://www.arcadiaimages.com

DEDICATION

This book is dedicated to the students, alumni, faculty, staff, and administrators, both past and present, who have made Delaware State a place of opportunity for so many to learn. Truly, "Only the Educated are Free."

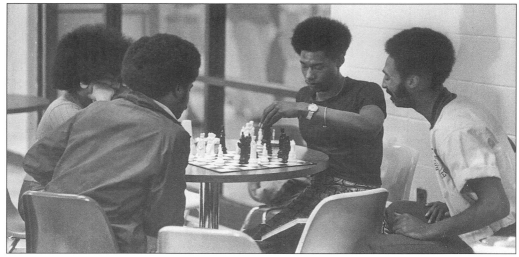

These students are relaxing over a game of chess in the Martin Luther King Jr. Student Center in 1973.

CONTENTS

ACKNOWLEDGMENTS

There are many people that I would like to acknowledge for their assistance during the completion of this book. The first person is my wife, Dinah L. DeMoss. Without her devoted support, I would not have accomplished much of what I set out to do during my academic career at Delaware State University.

During my quest for information and photographs, I received help from many devoted faculty and staff members and administrators at Delaware State University. A special thanks goes to Drexel B. Ball, executive assistant to the president, who has supported my efforts over the years and especially this project. Next, I would like to thank Dr. William B. DeLauder, president of Delaware State University, for his support of this project and my many other endeavors. I would also like to thank Dr. Billie Hooker, vice president for University Advancement and the staff in Public Relations, who contributed their time in locating photographs for this book. In addition, I want to thank Lorene Robinson, director of Alumni Affairs, who assisted in providing many of the photographs for this book. A special thank you goes to Ms. Robinson for her kind review, assistance, and comments on the manuscript. Also, I want to thank Dr. Akwasi Osei, my friend and colleague. Dr. Osei has provided me with much of my inspiration in my research and teaching of African-American history. Finally, I want to thank Professor Milton L. Cooper in the music department at Delaware State University for providing material on Clifford Brown and photographs of the band and musicians over the years.

There were many others from outside the university who assisted in the completion of this book. I would like to thank Mr. George Evans for contributing photographs. Mr. Evans graduated in 1934 from Delaware State and was among the first class to graduate with bachelor's degrees. Many thanks also go to the Hagley Museum and Library, the Library Special Collections at the University of Delaware, and the Delaware Public Archives.

Finally, I want to thank my parents, Clifton and Berdella Skelcher, for supporting me in all of my endeavors.

INTRODUCTION

Students from Delaware State like Solomon Gibbs (see page 2) of Star Hill achieved the high standards of excellence set by the school and demanded by the faculty and administrators. Following graduation, alumni maintain these high standards, challenging new students to attain the same goals as they had.

From its beginning as a fledgling college, Delaware State, born in the age of segregation, has taken a leading role in the establishment of equal higher education for African Americans. Following desegregation in the 1950s, Delaware State has taken the lead in educating all students coming from disadvantaged backgrounds. Students from Delaware State, like Homer Minus, challenged segregation in higher education leading to the desegregation of the first Southern institution of higher learning, the University of Delaware. Ethel Belton, one of the litigants in the 1954 *Brown v. Board of Education* case, attended Delaware State in the 1950s. Many Delaware State athletes have gone on to achieve great success, such as San Francisco 49ers football standout John Taylor who caught the winning touchdown pass in Super Bowl XXII. In 1970, President Richard M. Nixon appointed former president of Delaware State Jerome Holland to serve as ambassador to Sweden.

African Americans struggled in the years following the Civil War to build free and independent communities. This included the establishment of institutions that would help them build strong and enduring citizens. The centerpieces of African-American communities in Delaware, and throughout the nation, were churches. Flowing from them were other community institutions such as civic and fraternal organizations, businesses, and labor groups. Above all else, African Americans understood the key to empowering themselves was in pursuing an education.

Following the Civil War, religious groups like the Society of Friends and the Methodist Episcopal Church championed educational opportunities for African Americans in Delaware. Members of these groups came together in Wilmington, Delaware, in 1867 to establish the Delaware Association for the Moral Improvement and Education of the Colored People in Delaware. From this point, the Delaware Association worked with the Freedmen's Bureau and local African-American communities to build an educational system for blacks in Delaware. Many members of the Delaware Association also participated in the founding of Delaware State College for Colored Students in 1891.

In 1890, the U.S. Congress passed the Second Merrill Land Grant College Act in response to a financial crisis among colleges supported by the original act passed in 1862. The act required that states must allow African-American students to attend colleges receiving funds. If not, then states had to establish separate colleges for African-American students. Throughout the "segregated South," states established separate institutions of higher learning for African Americans during the 1890s including the state of Delaware.

Members of the General Assembly in Delaware responded to the provisions of the Second Merrill Land Grant College Act by establishing the State College for Colored Students on May 15, 1891. The state purchased the Loockerman estate near Dover, the state capital, and began holding classes in the former manor house the following year. Ironically, slaves once worked the land on the Loockerman estate in the late 18th and early 19th centuries. The first president of Delaware State was a white man, Wesley Webb, who served until 1895.

The first African-American president was William C. Jason, who served the longest term of a Delaware State president, from 1895 to 1923. It was Jason who placed the new college on a solid foundation. This remarkable achievement came at the height of "Jim Crow" segregation in the

state and the nation. During his administration, Delaware State saw the expansion of the physical plant and academic and athletic programs, as well as a growing number of students, faculty, and administrators.

Richard S. Grossley, who served as president from 1923 to 1942, led Delaware State through a period of renewal. Philanthropist Pierre S. duPont contributed funds for the construction of new buildings on the campus, including the addition of a new preparatory and high school building. Before this, African Americans had to attend O.O. Howard High School in Wilmington. Grossley introduced a four-year baccalaureate degree program in 1932. In 1934, the first class of five students graduated with bachelor's degrees.

From 1942 to 1953, Delaware State experienced several challenges resulting from the spirit of fighting fascism in Europe during World War II. At the onset of WW II, Delaware State was one among five historically black colleges and universities that trained pilots through the 1939 Civilian Pilot Training Program. Many African-American pilots from these programs went on to serve in the new all-black Army Air Corps, better known as the Tuskegee Airmen. From their experiences in WW II, many veterans returned from war and entered colleges and universities through the G.I. Bill. Delaware State was no exception. School officials responded to the new demand by building temporary housing for the students. Along with the growth of the school, Delaware State saw the change in its name from the State College for Colored Students to Delaware State College in 1947.

In addition, Delaware State faced the challenges of the growing Civil Rights Movement in the country that demanded desegregation of public schools. Students at Delaware State led the fight to desegregate the University of Delaware in 1948. The students won their case, making the University of Delaware the first Southern public school to desegregate in the country. This was an important first step toward the desegregation of all public schools in the state, with two important cases being a part of the *Brown* decision of 1954. This decision overturned the "separate but equal" doctrine.

The 1950s saw an era of calm, stabilization, and growth at Delaware State. Jerome Holland guided Delaware State back to some semblance of normality following the previous years of turbulence. In many respects, Delaware State reflected the nation as a whole. There was a general optimistic belief in the future and the value of education increased in the minds of African Americans. This was also the era of desegregation not only for white schools, but also for Delaware State; the first white student was admitted in 1956.

During the Luna Mishoe administration from 1960 to 1987, Delaware State faced the challenges of the Cold War and the Civil Rights Movement. During these years, Mishoe, a mathematician, embraced the call for an expansion in the sciences. There was an expansion of the undergraduate programs in the sciences and the adoption of graduate programs also. The physical plant and number of Ph.D.s among the faculty also expanded. At the same time, students from Delaware State embraced the Civil Rights Movement. This came to a crashing end following the assassination of Martin Luther King Jr. in 1968. Students protested on campus leading to the introduction of National Guard and the closing of the school.

In the 1970s, the school experienced a long period of calm. During this calm, Mishoe returned to his mission, pushing for continued growth in science programs, the expansion of the physical plant, and the recruitment of faculty with terminal degrees.

The William B. DeLauder years from 1987 to the present have seen Delaware State moving forward into a new millennium. Symbolic of this time period has been the change of status from a college to Delaware State University. President DeLauder also changed the appearance of the campus and improved the quality of faculty and academic programs. Clearly, Delaware State University is making its mark in the new millennium.

The history of African Americans is one of the most underdeveloped topics in historical scholarship. African-American history in Delaware is even more neglected, with only three published books on the topic. Hopefully, this book will generate interest in the rich African-American history of Delaware through its words and images.

One

CAMPUS SETTING OVER THE YEARS

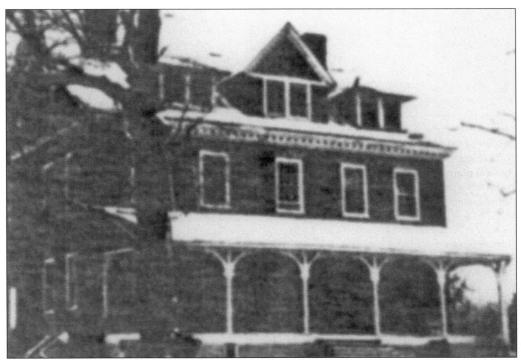

On February 2, 1892, the State College for Colored Students in Delaware began classes in Loockerman Hall. The first floor held administrative offices and the second floor contained classrooms and faculty offices. The student dormitory was located in the third-floor attic.

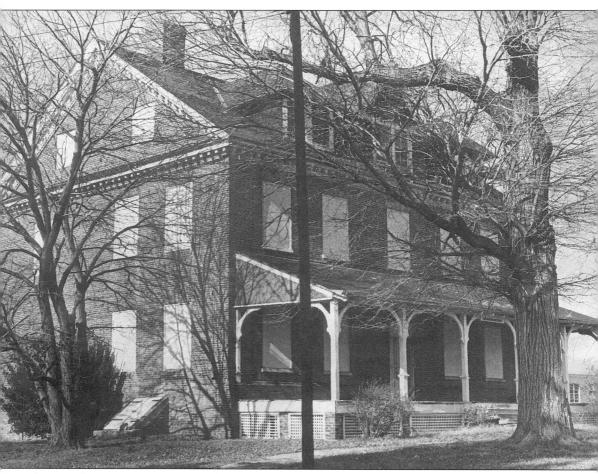

As Delaware State expanded over the years with the addition of new buildings, Loockerman Hall fell into disrepair. Still, it retained its noble and majestic presence.

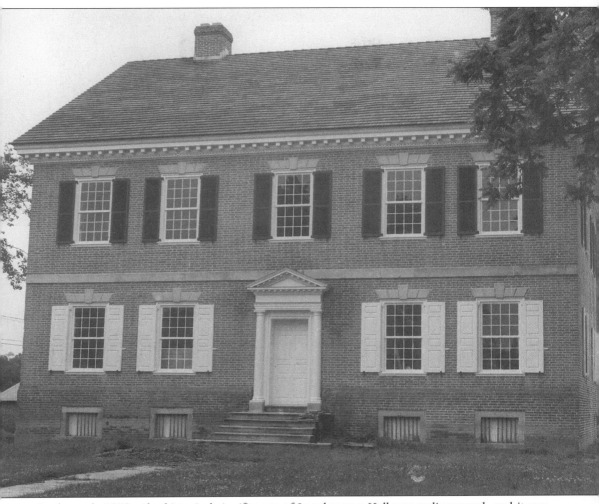

In the early 1970s, the historical significance of Loockerman Hall was rediscovered, and it was recognized on the National Register of Historic Places. Later, the National Park Service listed Loockerman Hall as one of the 11 most historically significant buildings on historically black colleges and universities. With this recognition, Delaware State was able to restore the building to its 18th-century appearance.

This is an early view of the historic "quad" on the Delaware State campus. Pictured from left to right are Lore Hall, built in 1904 as the first women's dormitory; Loockerman Hall, built in the

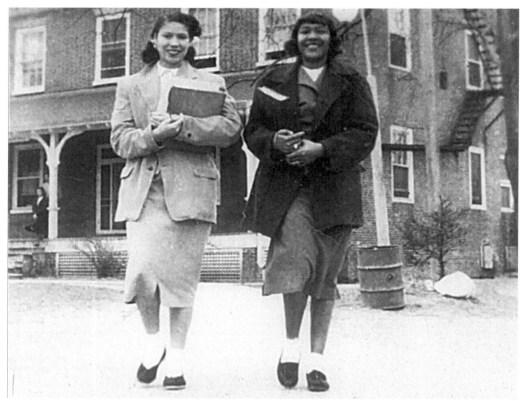

Students continued to use Loockerman Hall for classes well into the 1930s and 1940s. These young women are shown walking across the historic quad at Delaware State in the 1940s.

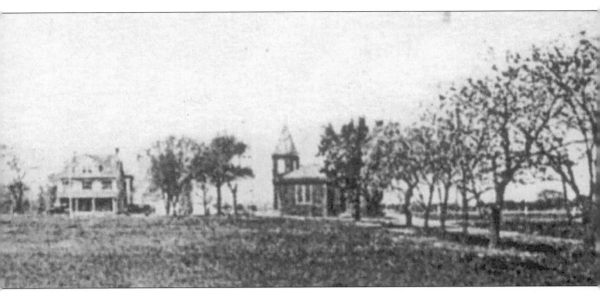

18th century as the first building used at Delaware State; Jason Hall; and Thomasson Hall, the first new building constructed on the campus by students.

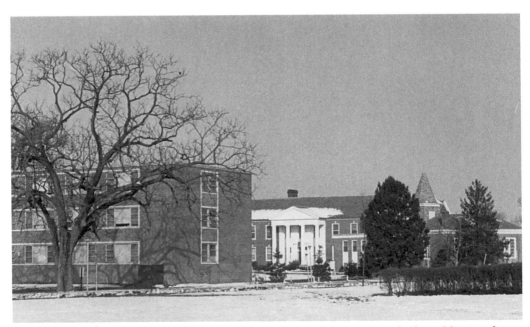

The historic quad of Delaware State has changed over the years with the addition of new buildings, such as Laws Hall in the foreground and Conrad Hall in the center background.

Thomasson Hall once served as the college chapel and library. Reportedly, at the turn of the century, male students built Thomasson Hall from bricks remaining from the old slave quarters on the Loockerman plantation. In the early years of Delaware State, male and female students could only socialize together once a month in the chapel.

Lore Hall was one of the first buildings constructed on the Delaware State campus in 1904. It was built as a women's dormitory. (Courtesy of Hagley Museum and Library, Wilmington, Delaware.)

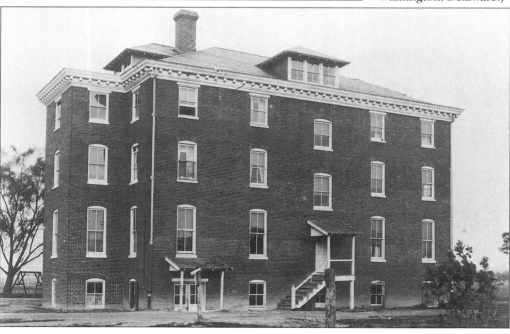

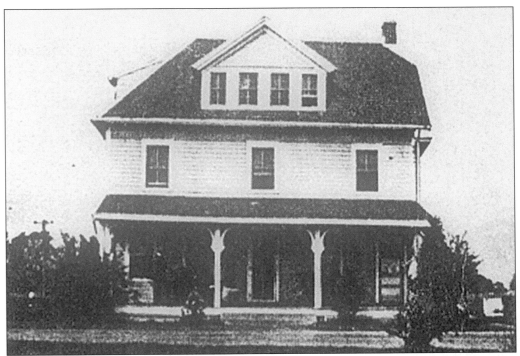

Jason Hall was named after President William C. Jason and served as the President's House until the 1920s, when Pierre S. duPont donated funds to build a new residence for the president of Delaware State.

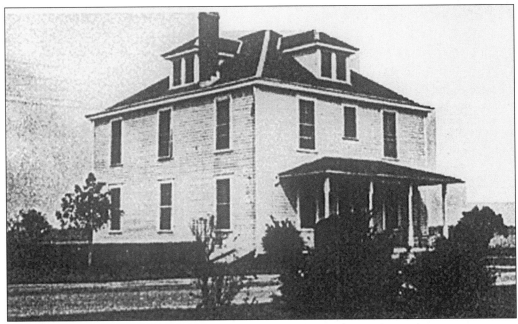

Cannon Hall built in the early 20th century and served as a dormitory for students at Delaware State.

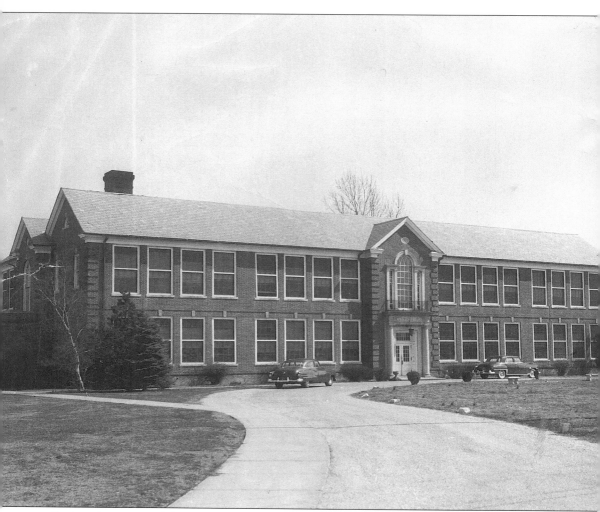

During the 1920s, philanthropist Pierre S. duPont donated almost $1 million to the Delaware Service Citizens Auxiliary Association to rebuild schools for African Americans in Delaware. DuPont dedicated a portion of the funds to construct new buildings on the campus of Delaware State. One of those buildings was Delaware Hall, shown in this photograph.

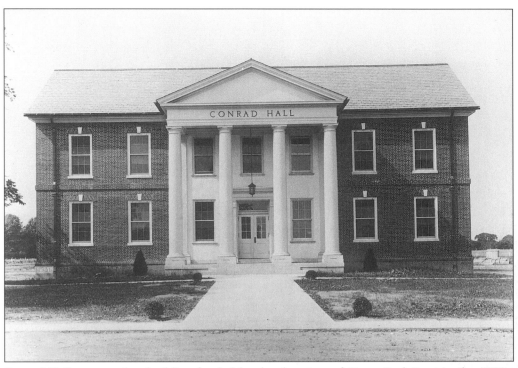

Conrad Hall was another building funded by the donation of Pierre S. duPont in the 1920s. (Courtesy of Hagley Museum and Library, Wilmington, Delaware.)

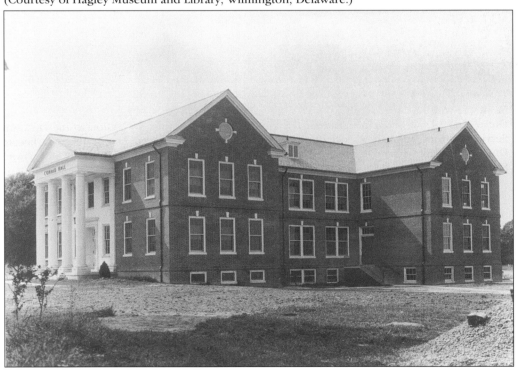

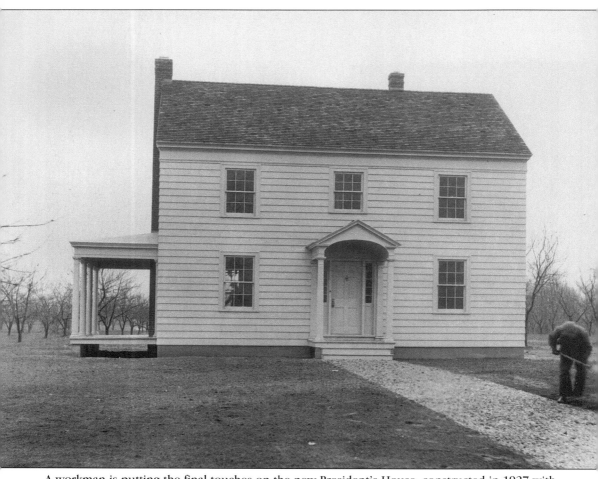

A workman is putting the final touches on the new President's House, constructed in 1927 with funds provided by Pierre S. duPont. The house still serves as the residence of the president of Delaware State.

DuPont funds were also used for the construction of new faculty and administrative housing on campus, such as the Clark/Arnold House (foreground), the Robinson/Jefferson Cottages (middle), and the President's House (background). These new residences were very important for Delaware State during the days of segregation.

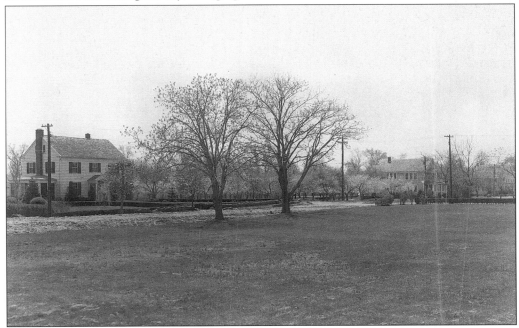

This is an early scene showing the President's House, the Robinson/Jefferson House, and the Clark/Arnold House lining Old College Road.

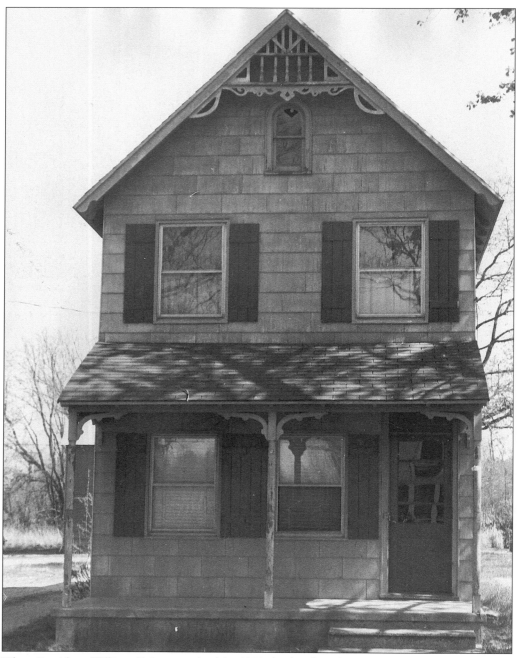

When President William C. Jason retired in 1923, he lived in the Jason House located on New College Road near the Delaware State campus. The house is still owned by the Jason family.

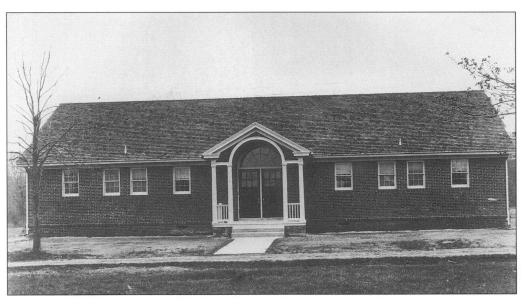

Before 1923, if African Americans wanted to attend high school, they had only one choice—O.O. Howard High School in Wilmington. With the support of Pierre S. duPont, Delaware State established a preparatory school on its campus, making it the second high school in the state for African Americans. (Courtesy of Hagley Museum and Library, Wilmington, Delaware and State Public Archives, Dover, Delaware.)

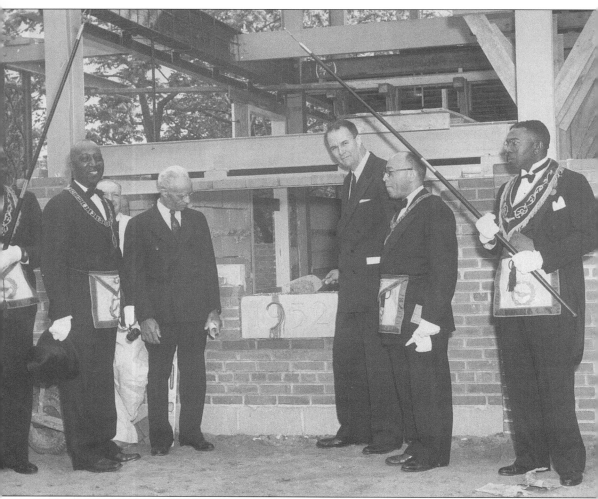

Following WW II, Delaware State became accredited as a four-year degree-granting institution by the Middle States accrediting body. In addition, the G.I. Bill afforded many returning veterans the opportunity to obtain a college degree, which led to an increase in the number of students on campus. In response, Delaware State expanded with the construction of new buildings like Tubman Hall, a dormitory for women. Shown in this photograph are President Maurice E. Thomasson (third from left) and Governor Elbert N. Carvel of Delaware (fourth from left) surrounded by members of the Prince Hall Masonic Lodge of Delaware as they lay the cornerstone in 1952.

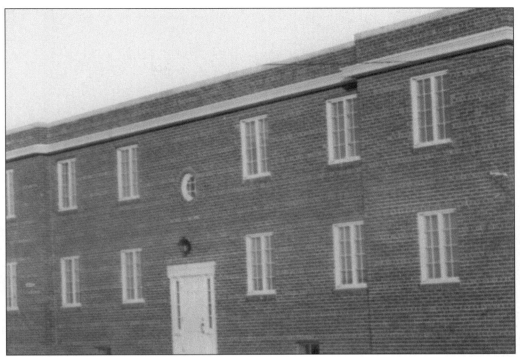

Kent Apartments were also built during the 1950s to accommodate faculty and administrators on the Delaware State campus.

The athletics department and the department of health and human performance are located in Memorial Hall, pictured above and built in the late 1950s during the Holland administration.

Later, the school added a multifunctional sports facility, in which the athletic department is located. This facility contains a gymnasium used by the basketball and wrestling teams as well as by physical education classes. It also houses racquetball courts, weight rooms, exercise rooms, and a swimming pool.

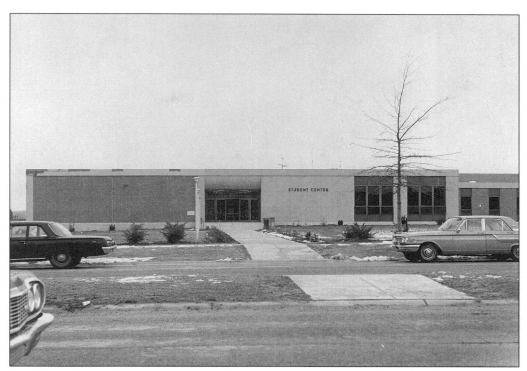

In 1968, Delaware State completed a student center on campus not long after the assassination of Martin Luther King Jr. In his honor, Delaware State officials named the new building the Martin Luther King Jr. Student Center.

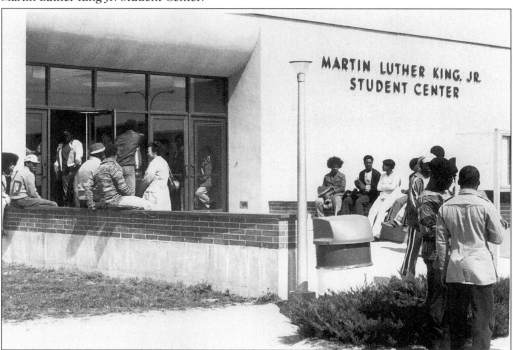

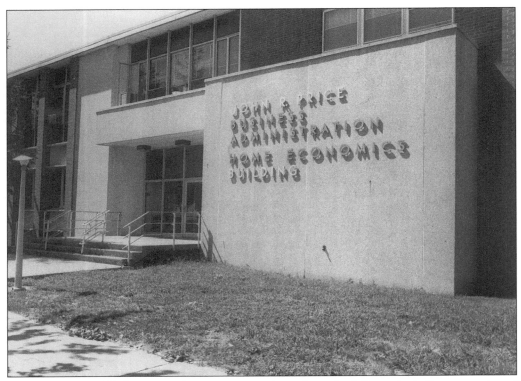

Delaware State added new graduate programs in various disciplines, including a master of business administration program located in the Price Building and advanced programs in biology and chemistry located in the Science Center.

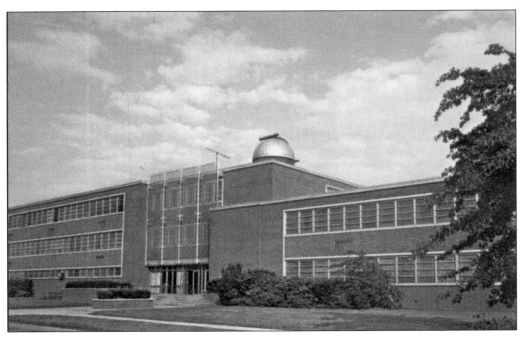

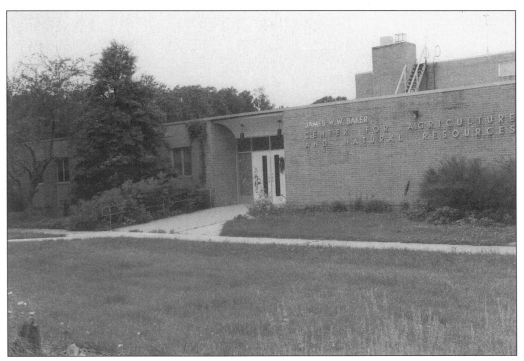

Traditionally, land grant colleges have strong agricultural programs. Delaware State has earned an international reputation stemming from its research in agriculture and aquaculture.

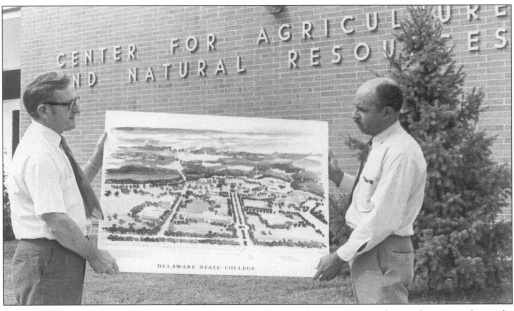

Ulysses Washington, professor of agriculture and natural sciences, is shown here on the right with an unidentified faculty member displaying a new landscape design for the campus in 1971.

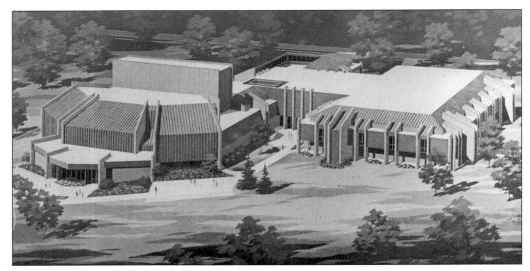

During the 1970s, Delaware State continued to grow with the addition of the new Education and Humanities Building. Pictured above is the architectural rendering of the building.

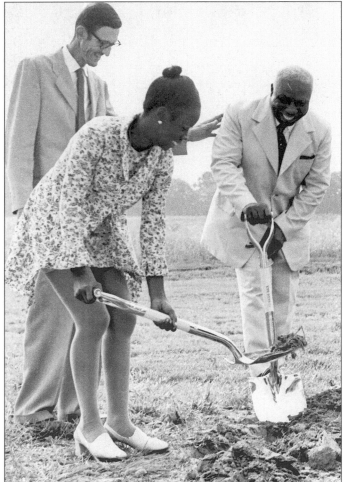

This photograph shows the groundbreaking ceremony for the Education and Humanities Building on September 9, 1971. Pictured from left to right are Walton Simpson (president of the board of trustees), Vinel Ezekiel (Miss DSC), and Luna I. Mishoe, president of Delaware State.

The face of Delaware State has undergone continuous change since its beginning in 1891, but it has always provided an inspirational setting for learning.

The William C. Jason Library was expanded during the 1990s. On the front entry wall is a bas relief sculpture by artist Bernard Feltch.

The Luna I. Mishoe Science Center was added to the existing Science Center. This facility holds modern laboratories for conducting experimental research in such areas as AIDS and asbestos-related diseases.

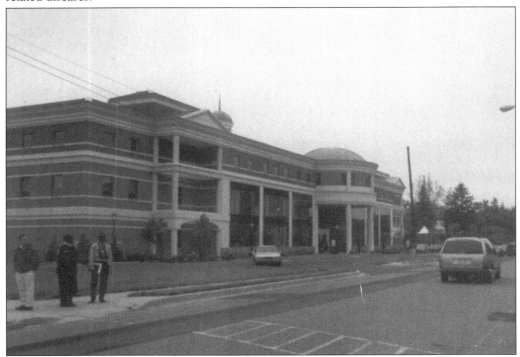

The latest building added to the campus is a state-of-the-art business management building.

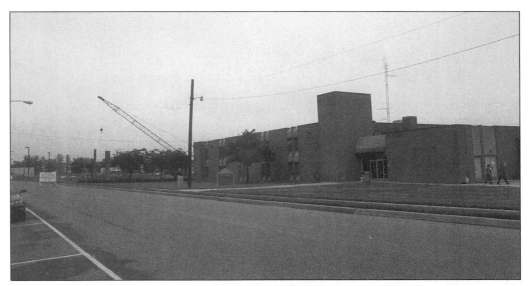

The ETV Building holds mass communications and the department of history, political science, and philosophy. The new administration building is currently being constructed to the side of the ETV Building.

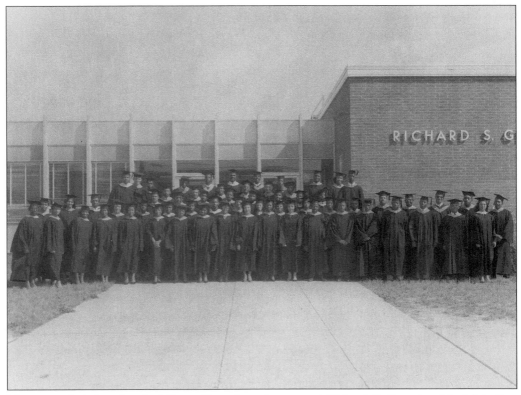

The new administration building will replace the current Richard S. Grossley Administration Building, shown here with the 1962 graduating class posing in front of it.

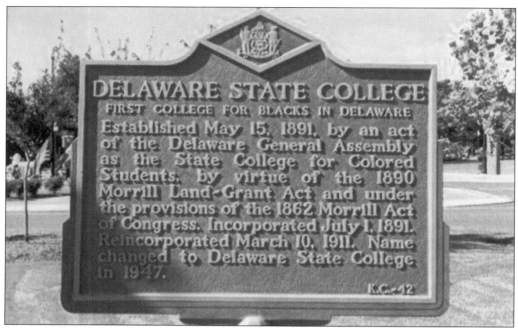

Delaware Division of Historical and Cultural Affairs placed this sign on the campus indicating its historical significance to the state.

On July 1, 1993, Delaware State College became Delaware State University, reflecting its true status as an institution of higher learning.

Two

THE PRESIDENTS

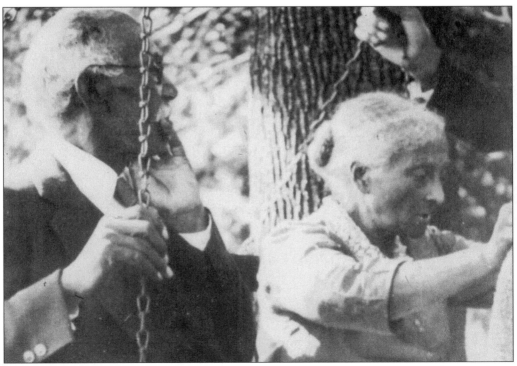

The presidents of Delaware State have worked hard to make the school a leading academic institution of higher learning. No one reflected this vision more than Mr. William C. Jason, the second president of Delaware State. Mr. and Mrs. Jason are shown here enjoying their latter years.

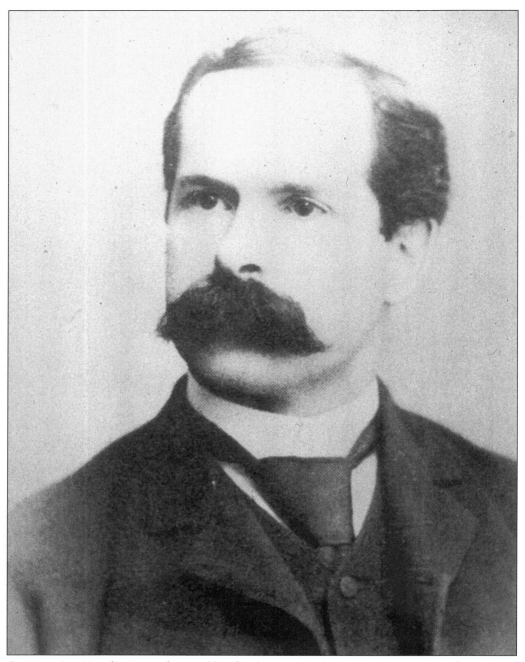

On May 15, 1891, the General Assembly of Delaware established the State College for Colored Students. At that time, Wesley P. Webb (1891–1895) was appointed the first president of the school. He has been the only caucasian president in the school's history.

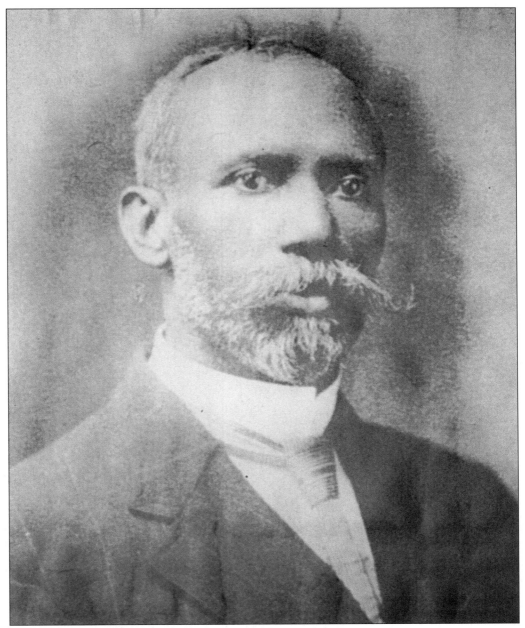

William C. Jason (1895–1923) was the first African American to serve as president of Delaware State. President Jason was responsible for expanding the academic programs at Delaware State, beginning with the addition of a teachers education program. Jason was the longest-serving president in Delaware State history.

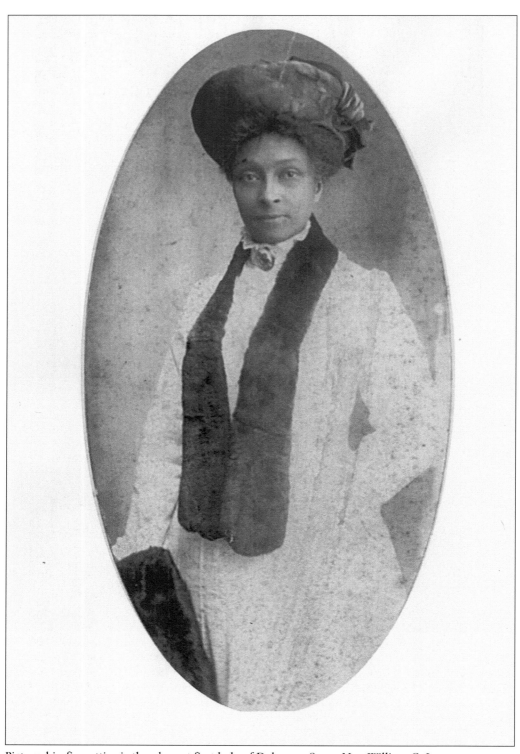

Pictured in fine attire is the elegant first lady of Delaware State, Mrs. William C. Jason.

Richard S. Grossley was president from 1923 to 1942, and guided Delaware State through an era of renewal. During the 1920s, philanthropist Pierre S. duPont decided to contribute about $1 million to the Delaware Service Citizens Committee Auxiliary Association to rebuild the schools for African Americans in the state. In the process of this effort, duPont brought in several school consultants to conduct surveys of existing schools and to develop plans for new schools. He also sent consultants to review the physical plant of Delaware State. From this, duPont supported a plan to construct new buildings on the campus including the second high school for African Americans in the state.

The years of President Richard Grossley's administration saw the beginning of a four-year baccalaureate degree program. As Delaware State grew in its student body and its faculty, there was an accompanying demand to introduce a full four-year degree program. The first graduation of students in the four-year program took place in 1934.

Howard D. Gregg (1942–1949) served as president when the school's name was changed from State College for Colored Students to Delaware State College in 1947. While he was president, Delaware State survived the WW II years and saw the emergence of the Civil Rights Movement. During that time, returning G.I.s entered colleges, swelling the number of students that had previously been seen. It was also during his administration that a group of students from Delaware State sued the University of Delaware for admittance. Since 1897, the public education system in Delaware had been legally segregated. This suit led to the beginning of the end of segregation in Delaware, and the University of Delaware became the first Southern public institution of higher education to admit African-American students following the 1948 suit.

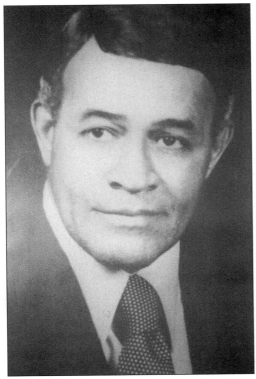

Oscar J. Chapman served as president for a brief term, from 1949 to 1951. Never receiving proper levels of funding during Chapman's tenure, Delaware State did not have enough funds to cover many of the basic classes such as history. There was even discussion among the state legislators as to whether to close Delaware State and send the top students to the University of Delaware. Some of this discussion stemmed from the recent desegregation of the University of Delaware. Legislators thought that since African-American students could then attend the University of Delaware, there was no longer any need for a separate school.

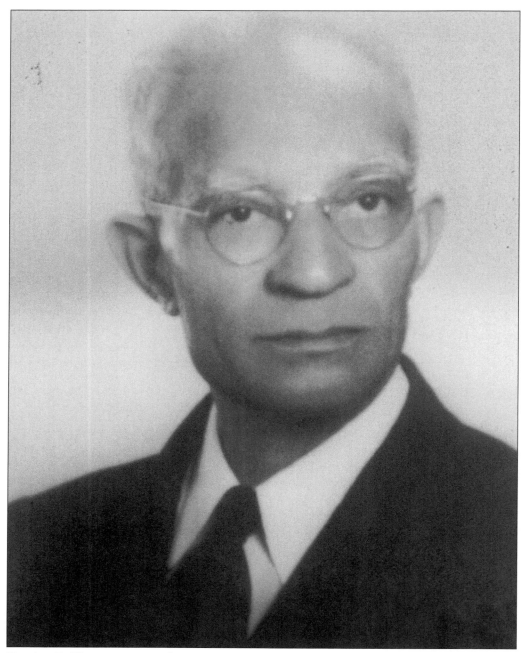

Maurice E. Thomasson served as acting president from 1951 to 1953. During Thomasson's administration, African-American students from public schools in Delaware sued the state for admission into white schools, thus challenging years of segregation in the state. Thomasson testified in court cases that eventually made their way to the U.S. Supreme Court and were known as *Brown v. Board of Education, Topeka, Kansas, 1954*.

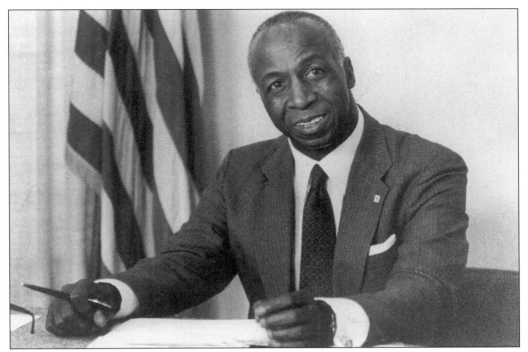

From 1953 to 1960, Jerome H. Holland served as president and saw the rebirth of Delaware State. The state of Delaware boosted its financial support for Delaware State, and Holland was responsible for building a new foundation for the school. After leaving Delaware State, Dr. Holland became the president of Hampton University. In 1970, President Richard M. Nixon appointed Holland to serve as ambassador to Sweden.

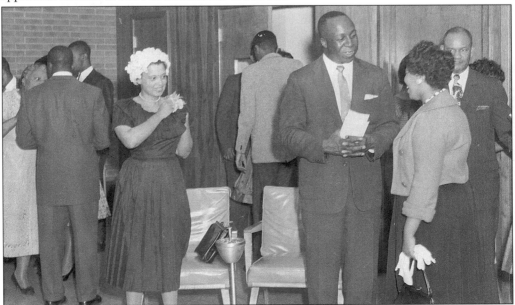

Mrs. Holland is seen on the left with President Holland receiving guests at a Delaware State function during the 1950s.

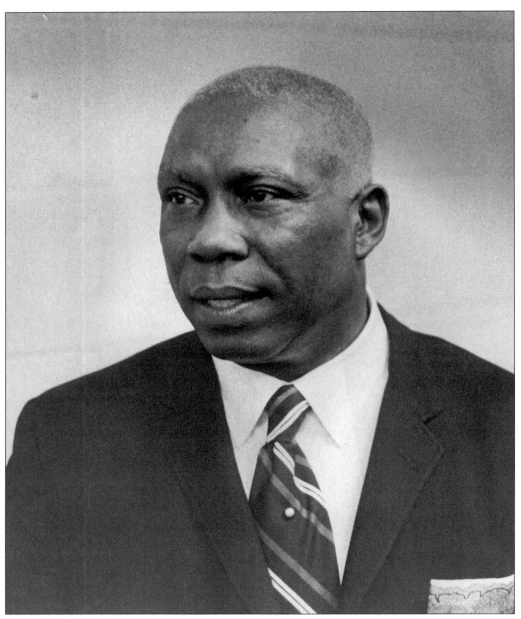

Holding the second-longest term among presidents at Delaware State, Luna I. Mishoe served from 1960 to 1987. Under President Mishoe's leadership, Delaware State expanded its academic programs to include graduate programs in biology, business administration, chemistry, education, physics, and social work.

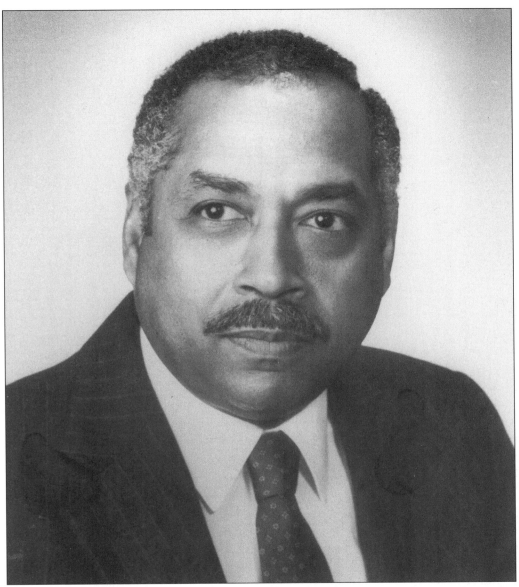

The current president of Delaware State is William B. DeLauder. His tenure began in 1987 following the retirement of President Mishoe. President DeLauder has successfully continued the legacy of his predecessors by expanding academic programs, such as the addition of a graduate degree program in historic preservation. Through adherence to high academic standards, President DeLauder has managed to attract increasing numbers of students with excellent academic credentials. But his most remarkable achievement has been the expansion of the physical plant of Delaware State. In 1993, Delaware State achieved university status in recognition of its high academic caliber, generated over the years by not only President DeLauder, but from the hard work of past presidents. President DeLauder is also the recipient of the prestigious Thurgood Marshall Black Educational Achievement Award presented by the editors of *Jet* and *Ebony* magazines. In addition, the board of directors of the Thurgood Marshall Scholarship Fund presented Dr. DeLauder with the Thurgood Marshall Scholarship Fund Award.

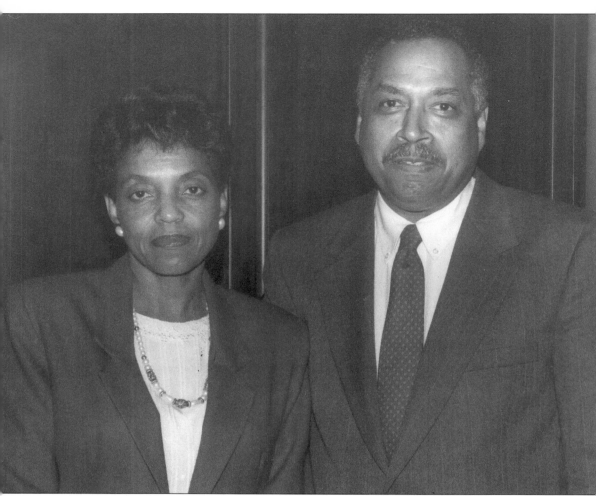

President and Mrs. DeLauder have shown a remarkable commitment to higher learning not only in Delaware, but throughout the nation. Together, Dr. and Mrs. DeLauder led Delaware State into the new millennium.

Three

ACADEMICS

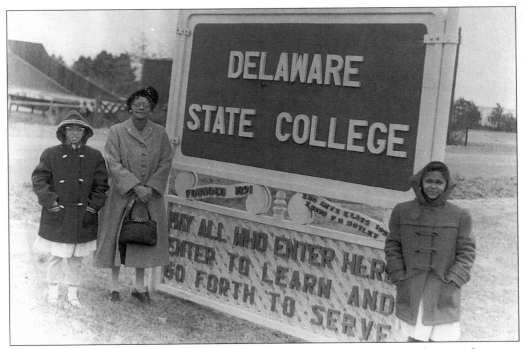

Felmon D. Motley designed and constructed this sign in 1952, and its message became the motto of Delaware State. Shown here are Mr. Motley's mother and two daughters.

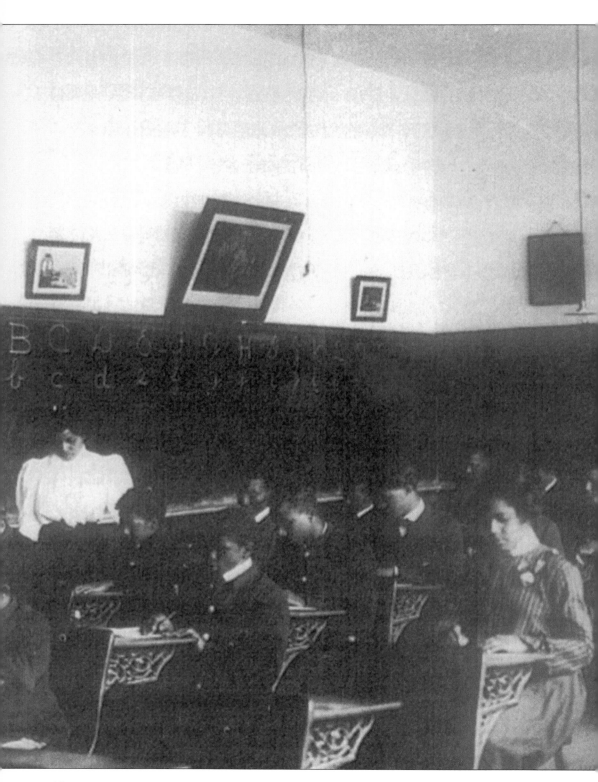

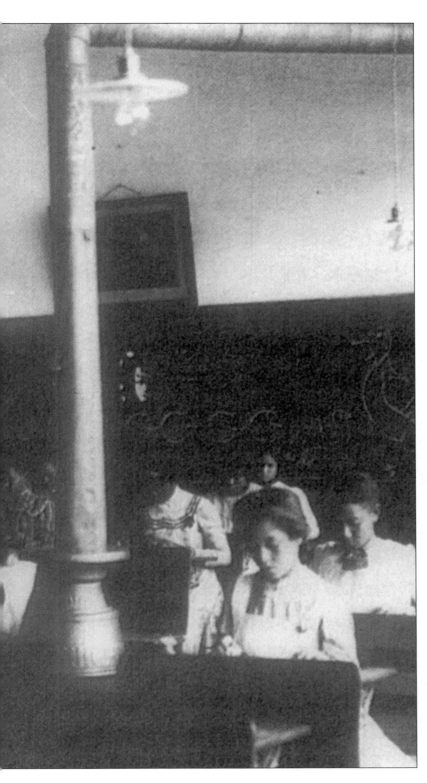

Born in the age of segregation, this proud institution weathered the storm of "Jim Crow" because of its persistence to instill in its students the truth that "Only the Educated are Free." Students could study and after four years earn a bachelor of arts degree, an engineering degree, or a bachelor of science degree in agriculture, chemistry, or scientific study. Here students are fulfilling Delaware State's vision in a classroom located in Loockerman Hall around 1910.

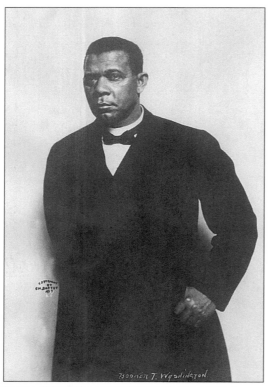

On July 4, 1910, Booker T. Washington toured the state of Delaware accompanied by William C. Jason, president of Delaware State. Jason introduced Washington during his tour. During his stop in Dover, Washington encouraged African Americans to remain in the rural countryside and to continue farming the land. He also encouraged male students to study manual or mechanical arts and women to study the domestic arts. (Courtesy of Library of Congress, Prints and Photographs Division , Reproduction Number: LC-USZ62-25624 (6-2).)

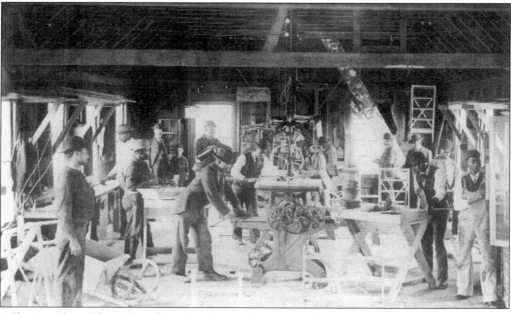

Following the philosophy of Booker T. Washington, Delaware State offered courses in the manual and mechanical arts. Male students took a two-year course in "shop" as a requirement, or they could substitute agricultural education and horticulture. This photograph shows teachers instructing students in woodworking, *c.* 1910.

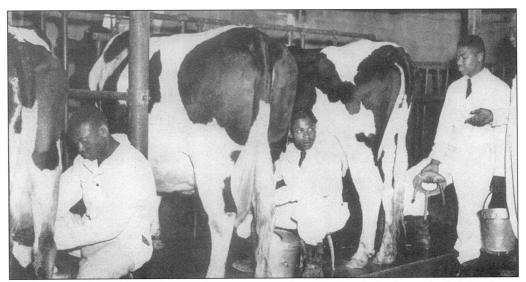

Like other land grant colleges, Delaware State emphasized a curriculum in agricultural science and the training of students in practical fields, such as preparing them for work in the dairy industry.

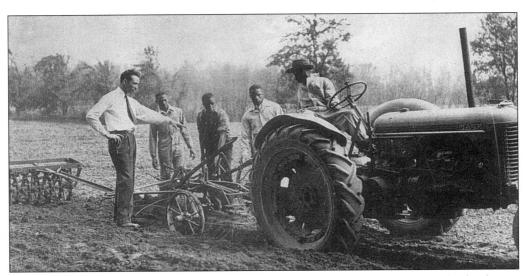

Practical training in the use of farm equipment and cultivation was also emphasized at land grant colleges. These students at Delaware State are receiving practical instruction in the field during the 1940s.

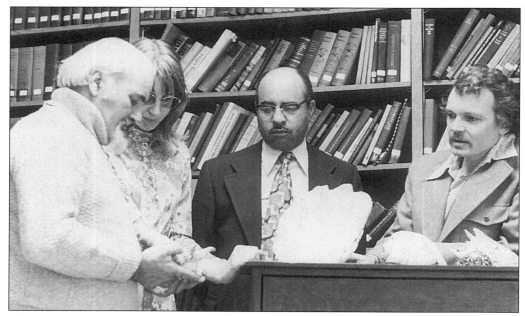

Agriculture continued to be an important academic discipline at Delaware State. Over the years, the agriculture department added several fields of study, including aquaculture, and faculty members have gained an international reputation for their research. Pictured from left to right, c. 1970s, are Dr. ? Jeens, unidentified, Mr. Ulysses Washington, and Dr. Norman Dill.

Because of its international reputation in agriculture, Delaware State was able to secure an academic agreement to exchange faculty and students with the Agriculture Institute of Yucatan, Mexico, in 1991. Shown here is a representative of the school with President DeLauder signing the agreement.

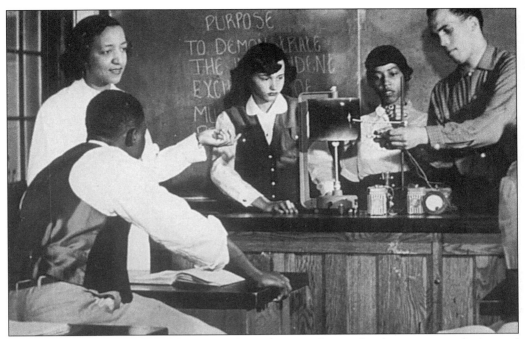

Along with an emphasis on agriculture, land grant colleges also have strong science and mathematics departments. Here, students conduct a science experiment, *c.* 1940s.

Dr. Harriet Williams is a symbol of excellence in chemistry and education. She attended preparatory school at Delaware State and graduated with the first class to receive bachelor's degrees from the school in 1934. She returned to Delaware State in 1946 to teach chemistry and later became chair of the department. Dr. Williams lived on campus until her death on January 8, 1999. Pictured on the right is Norman Oliver, president of the Student Government Association.

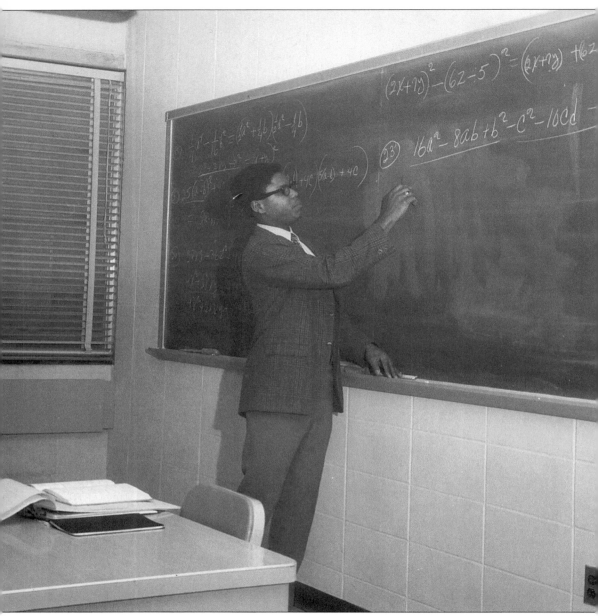

Mathematics is one of the strongest disciplines at Delaware State. Henry N. Tisdale was one of the outstanding math professors at the school, and currently serves as the president of Claflin College in Orangeburg, South Carolina.

Still teaching mathematics at Delaware State, Professor Allen Hamilton is seen writing problems on the chalkboard, *c.* 1970.

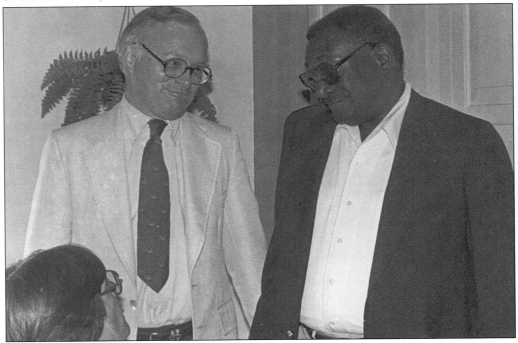

Merging science and mathematics, Dr. John Olson (left), director of the Cooperative Engineering Program, and Mr. Harry Washington (right), professor of mathematics, participated in the Summer Engineering Institute in 1979.

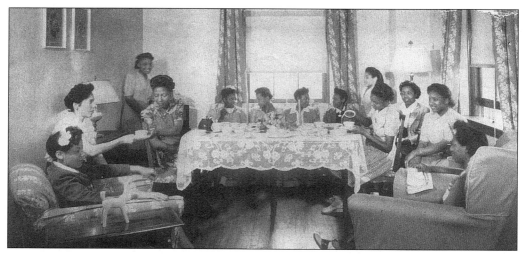

Delaware State also emphasized that female students should study the domestic arts. Home economics students are seen here holding a formal tea, *c.* 1940s.

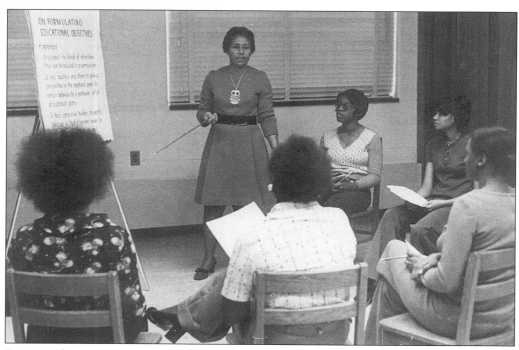

Dr. Eva Adams continues the tradition of teaching young women the domestic art of home economics in 1974.

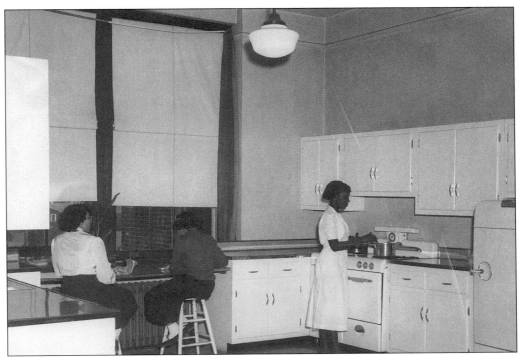

Here students and faculty are tasting the results of a cooking class in home economics probably during the 1950s or early 1960s.

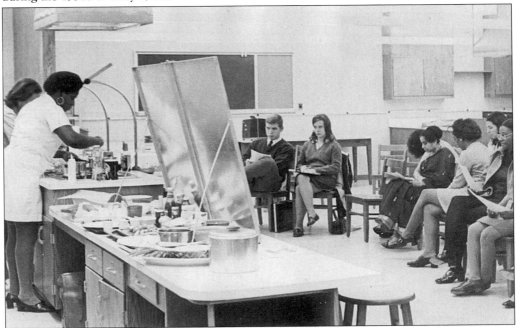

As the discipline matured, students learned nutrition as a science rather than a domestic responsibility. Here Mrs. Holden demonstrates fish cookery for the home economics department.

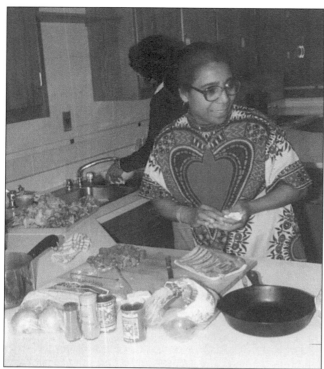

International students and faculty have prepared international cuisine at festivals. Here, Dr. Ora Bunch prepares African meat kebabs for a continuing education class.

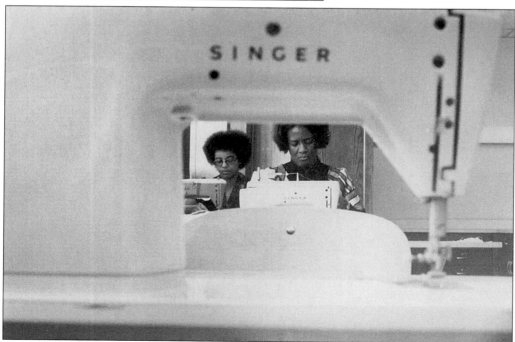

Students in home economics also learn how to design clothing and sew, as these two students are demonstrating. Audrey Daniels, right, is creatively practicing what she has learned from the dedicated faculty in home economics.

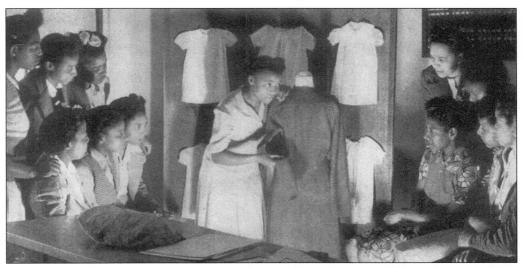

At the end of each year, home economics students in design organize a fashion show. This gives students an opportunity to show off their creative designs. These young home economics students in the 1940s were busily preparing for their fashion show.

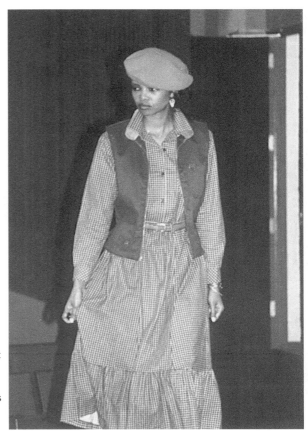

Since their beginning, fashion shows at Delaware State have taken on an ambience of commercial professionalism. Sharon Boone models the latest fashions at the Fall Fashion Show held on September 17, 1982.

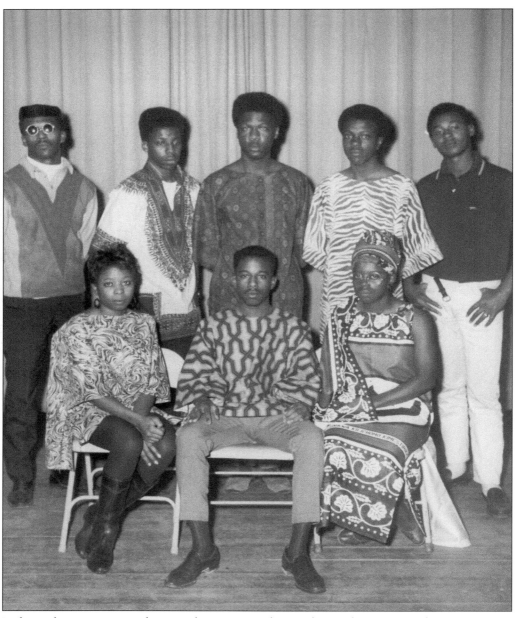

Fashions became so popular at Delaware State that students who were not home economic majors began holding shows. Students at Conwell Hall held an African Fashion Show in 1969.

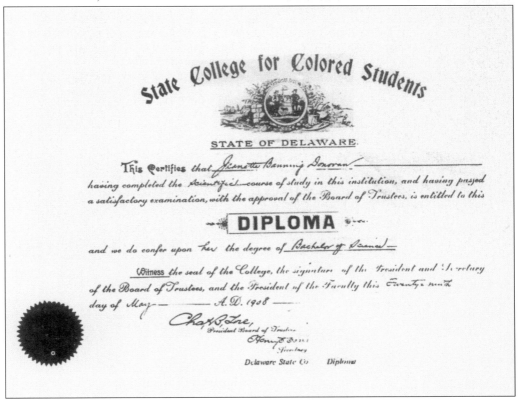

After African Americans established a public education system in Delaware following the Civil War, the demand for teachers increased. To meet this demand, Delaware State established a normal school in 1897. This was a three-year program, resulting in certification to teach. Graduating with a bachelor of science degree in 1908, Jeannette Banning Donovan-Turner went on to teach at the Sanfield Colored School to the west of Dover, Delaware.

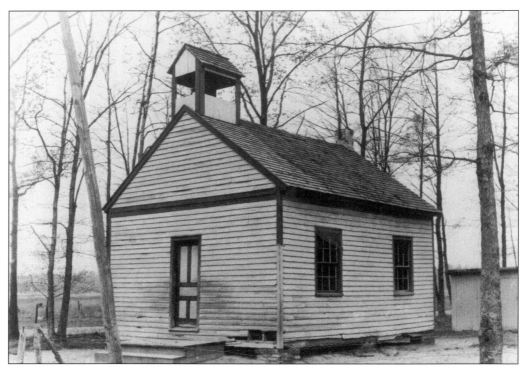

Teachers graduating from Delaware State taught in schools like the one shown in the above photograph. Upon graduation, Ms. Donovan-Turner taught in the Sanfield Colored School built in 1867 by the Delaware Association for the Moral Improvement and Education of the Colored People. (Courtesy of Hagley Museum and Library, Wilmington, Delaware.)

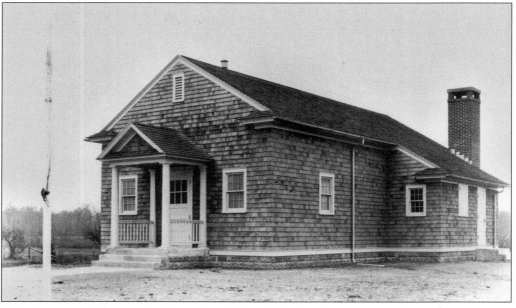

With the support of Pierre S. duPont, the old Sanfield schoolhouse was replaced with this newer state-of-the art building. (Courtesy of Hagley Museum and Library, Wilmington, Delaware.)

Summer Schol July 1911

CORRESPONDENCE

Application should be made at once accompanied by a fee of one dollar to insure assignment of room. This fee will be credited to "incidentals" on arrival of student.

OPENING

Students should report not later than the 1st that classes may be organized on Saturday, and school work begin at 8 o'clock Monday.

COURSES

Mrs. Alice M. Dunbar will give personal direction to the following courses of study assisted by competent teachers: Arithmetic, Lauguage, Geography, Nature Study, Reading, Drawing.

ADVANTAGES

Experienced instructors, supervision of County Superintendents, comfortable buildings, wholesome food, attractive and healthful surroundings, are some of the advantages offered to those who desire to further prepare themselves for responsiblities of teachers in the public schools.

EXPENSES

An incidental fee of one dollar will be charged each student.

Ten dollars will pay for board and lodging for one month. For a less period, board will be charged at the rate of three dollars per month.

Tuition will be free to teachers and candidates for teachers' certificates.

Others desiring to avail themselves of the opportunity will pay one dollar tuition in each subject pursued, in addition to the charge for board.

Ladies will have use of the laundry free.

EXAMINATIONS

Under the direction of the county Superintendents, examinations will be held at the close of the session covering the subjects pursued. Those giving satisfactory evidence of proficiency will receive certificates to teach in the public schools of the State.

TRANSPORTATION

Transportation between the college and Dover will cost 25 cts. for each person, 25 cts. per trunk, 10 cts. for each piece of hand baggage.

C. C. Showell is speuding a few days in Philadelphia.

The students enjoyed the social last Saturday evening.

The scrub team was defeated by Milford Monday the score being 9 to 3.

Mrs. Sterrett and son, and Mrs. A. B. Ruffin were visitors on the campus Mon.

Mr John W. Waters of the College Settlement attended Sunday afternoon's services.

The Rev. Morrishaw and wife favored us with their presence Sunday afternoon. The former participated in the services.

Rev. W. W. Taylor, of the A. M. E. Church, preached an interesting sermon at the College on Sunday. Tho bruised from having been thrown from his carriage and dragged several feet by his horse which had become frightened at an auto, yet this old gentleman of 81 presented the word of God as he sees it, in an original and enthusiastic manner. His wife accompanied him on this visit.

Pres. Jason and Prof. Cogbill visited Delaware College at Newark Monday and viewed the school battalion in dress parade. Our "Commandant," Prof. Cogbill writes these words to express his feelings in regards to the affair.

"My trip to Delaware College to witness the review, shall be numbered as one of the most interesting and at the time beneficial, I have ever taken. All that was presented by the battalion was worth travelling miles to see. But in view of the military spectacle presented by the cadets there, I cannot do less than award our boys highest praise for their relative efficiency especially when we take into account the difficulties under which they labor"

A "George Walker Memorial" will be held at the Howard Theatre, Washington D. C. May 30th, 31st; Mr. Jacob E. Jones has been invited to take part in the play appearing with such celebrities as Aida Overton Walker, Bert Williams and the celebrated violinist Clarence Cameron White. Mr. Jones is fast becoming known in musical circles in Washington and recently was sent for by Thomas Nelson Page to be complimented after having sung a solo at Howard University Vesper service.

In 1911, Delaware State expanded the teacher education program to a four-year bachelor of pedagogy degree program. During the 1916–1917 academic year, a Model Grade School was established, replacing the preparatory department. In addition, students could also complete four years of high school at Delaware State, the second high school in the state for African Americans. In 1923, Delaware State added a junior college division. As Delaware State graduates entered the public school systems as teachers, there emerged the need for a summer institute to help them keep up with current trends in pedagogy. This announcement shows that Alice Dunbar-Nelson was the director of the Summer Institute in 1911; she served as director from 1908 to 1914.

Noted for her contributions to the Harlem Renaissance, Alice Dunbar-Nelson directed the Summer Institute for Teachers at Delaware State for several years in addition to teaching at Howard High School in Wilmington. Dunbar-Nelson exemplified the caliber of teachers who have taught at Delaware State over the years. Following her divorce from noted poet Paul Lawrence Dunbar, she came to Wilmington in 1902 and began her teaching career at Howard High School. She also continued to write poetry, fiction, and plays while in Delaware. Along with her literary work, she was also a political activist working to secure the vote for women, improving education for African Americans, and lobbying for a federal anti-lynching law. Some of her more famous works include *Violets and Other Tales* (1895) and *The Goodness of St. Rocque* (1899). (Courtesy of Alice Dunbar-Nelson Papers, Special Collections, Morris Library, University of Delaware.)

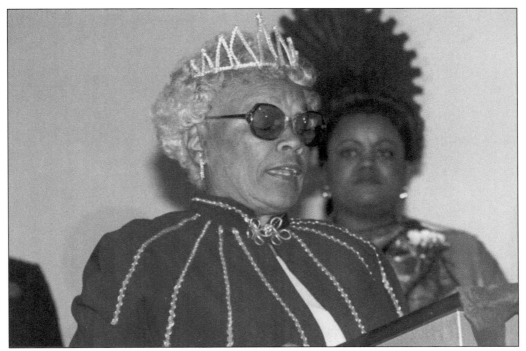

Delaware State has left a mark of excellence in education throughout the region, graduating such distinguished educators as Dr. Cora Norwood-Selby. She is shown here being crowned at the Delaware State Alumni Association Coronation. Paula Stokes is standing behind Dr. Selby.

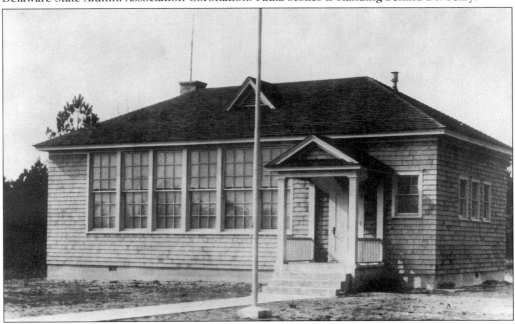

Dr. Selby taught at the Ross Point Colored School in Sussex County, Delaware, shown above. She is currently a member of the Delaware State University Board of Trustees. (Courtesy of Hagley Museum and Library, Wilmington, Delaware.)

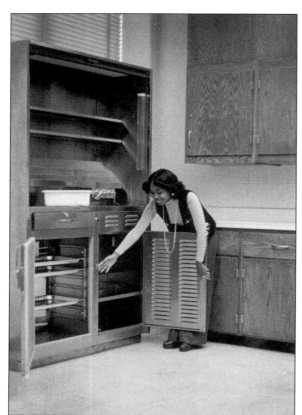

As Delaware State grew, so did its academic programs, offering new degrees in fields like social work and nursing. Mrs. Maxine R. Lewis is shown here examining the equipment in the Medicenter of the nursing department in 1974.

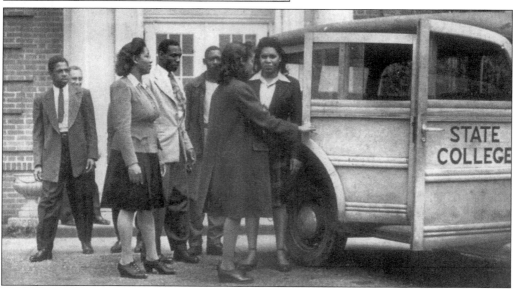

Delaware State also expanded its liberal arts and social sciences programs. These sociology students are boarding the famous "Green Hornet" bus to conduct field investigations for a class research project in the 1940s. In the 1950s, Delaware State established a center for the sociological study of segregation in Delaware under the leadership of Dr. Jerome Holland.

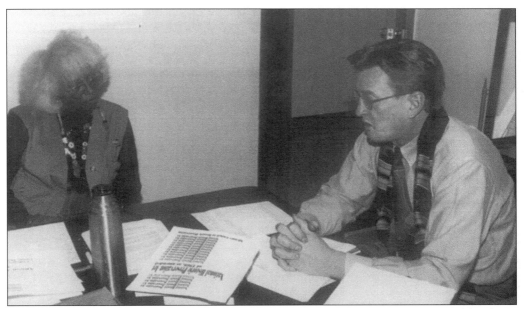

More recently, Delaware State launched its first graduate degree program in the liberal arts with a master of arts degree in historic preservation in the department of history, political science and philosophy, which is also the first among historically black colleges and universities. The author of this book, Bradley Skelcher, is discussing a problem with graduate student Flavia Rutkosky-Williams.

In 1971, the history faculty established the Phi Alpha Theta National Honor Society for students who excel in the study of history. Shown here are the first students to be inducted in the Sigma Tau Chapter of Phi Alpha Theta at Delaware State.

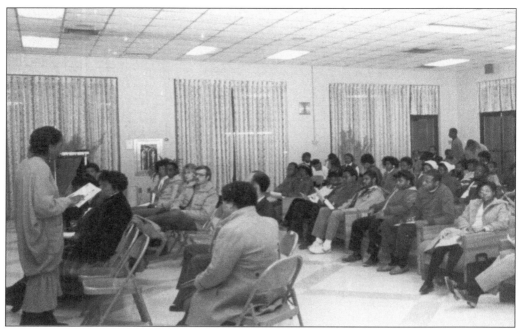

Like so many colleges and universities across the nation during the 1960s, students demanded the inclusion of black studies into the curriculum. Delaware State added it as a minor field of study, and it has instilled pride among the student body in their study of African-American history, literature, sociology and the other fields included in black studies.

Since 1972, the education and humanities building has held the various related departments in the humanities. This photograph shows the artistic design of its lobby.

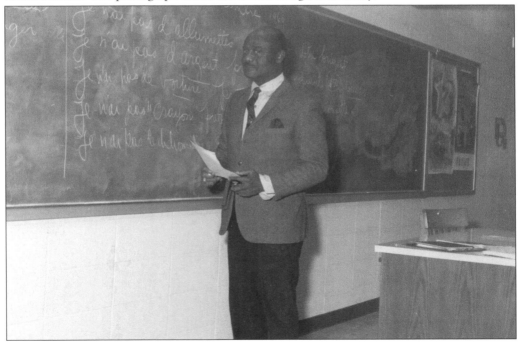

The number of courses available in the foreign languages has grown in strength over the years, since the days when students were required to study Greek and Latin. Delaware State modernized its curriculum and began offering instruction in Spanish, German, Italian, Kiswahili, and French. Professor Eugene Georges is shown here teaching French to his class, *c.* 1960s.

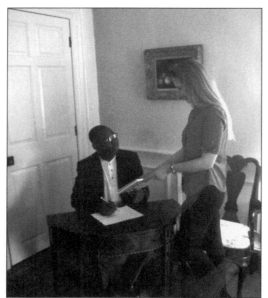

Distinguished Professor of English and world-renowned author F. Odun Bolagun has written several books of short stories and novels telling the story of Africans throughout history. He is also a renowned scholar in the field of literature and is an example of excellence among the faculty at Delaware State. He is shown here signing his book, *Adjusted Lives*, for graduate student in historic preservation Lorian Murajda.

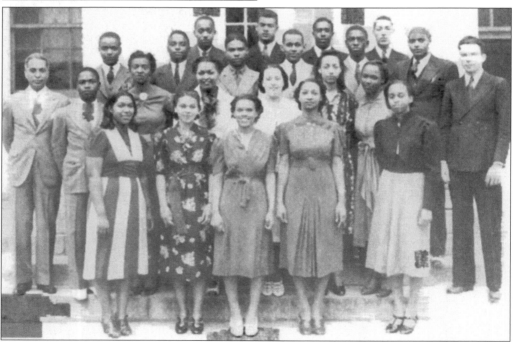

Within the humanities, faculty and students have not only excelled in literature, but also in the performing arts. Students in this photograph belonged to the State College Guild Players in 1939. From left to right are as follows: (first row) Bernice Chrisden, Catherin Hicks, Cora Norwood (president), Blance Miles, and Evelyn Munson (secretary); (second row) Mr. ? Hopson (director), William Stevenson, Bertha Seagers (treasurer), Emma Randall, Mary Morris, Barbara Anderson, Thelma Murray, and Clarence Warren (vice-president); (third row) Herman Jones, Theodore Johns, Clave Neal, Edward Buck, Maxwell Honemond, and John Parker; (fourth row) John Oscar Richmond, John Henson, James Evans, and George Ayers.

Students write and perform plays in the
education and humanities theatre.

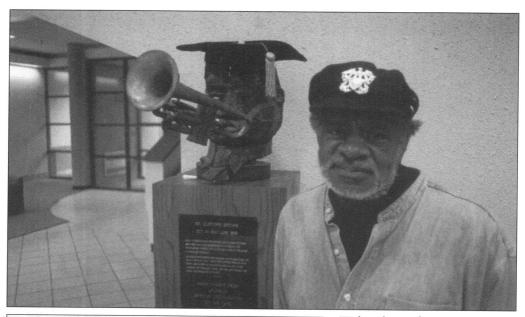

DELAWARE STATE COLLEGE
DOVER, DELAWARE
APPLICATION FOR ADMISSION TO THE COLLEGE

DIRECTIONS—To be filled out by the applicant in his own handwriting and returned to the Office of the Registrar, Delaware State College, Dover, Delaware.

Name of Applicant __BROWN__ ____CLIFFORD BENJAMAN____
(Please Print) Last Name First Name Middle Name

Home address __1013__ __POPLAR__ __WILMINGTON DEL.__
Number Street City State

Place of birth __1013 Poplar St. Wilmington, Del.__

Date of birth __October__ __30__ __1930__ Age in years __18__
Month Day Year

Height: feet __5__ inches __6__ Weight __134__ Church Membership __Methodist__

Married (Yes) (No) __No__ Children (Number) ____

Any physical disabilities? __None__ If so, what? ____

Father's name __Joseph R. Brown__ Mother's name __Estella A. Brown__

Address __1013 Poplar St. Wilm.__ Address __1013 Poplar St. Wilm. Del.__

Living or dead? __Living__ Living or dead? __Living__

Occupation? __Licensed Fireman__ Occupation? __Housewife__

Education: (Draw a circle around the highest year of school work completed)

Father: 1 2 3 4 5 6 7 8 (9) 10 11 12 College 1 2 3 4

 Please Name

Mother 2 5 11 (12) College 1 2 3 4

 Please Name

How many children in your family older than yourself? { Boys __4__ Younger? { Boys ____

 { Girls __2__ { Girls ____

Indicate name of college brothers or sisters have attended, if any __Delaware State__

__College, Lincoln University__
__Howard University__

In what ways, if any, have you contributed toward your own support while preparing for college? __By working__
__and saving as much as possible__

Are you able to meet your bill promptly? __No__

To be filled in by war veterans only

If you are planning to come under the jurisdiction of the Veterans Administration, check one of the following:

☐ Disabled Veterans Bill (Public Law No. 16)
☐ GI Bill of Rights (Public Law No. 346)

Within the performing arts, Delaware State has a musical tradition that reflects African-American musical heritage. Jazz great Donald Byrd is shown here standing next to a sculpture of Clifford Brown, designed by artist Arturo Bassols. After the untimely death of Clifford Brown, Dr. Byrd replaced him as trumpeter in the *Messengers*. Dr. Byrd is currently artist-in-residence at Delaware State University and is continuing the tradition of jazz set by Clifford Brown while he was a student at Delaware State.

Clifford Brown entered Delaware State in 1949 after receiving a music scholarship, despite the fact that the school did not have a music degree program. In his brief career, Brown played with many of the jazz greats like Max Roach, Sonny Rollins, Harold Land, Dinah Washington, Miles Davis, Dizzy Gillespie, and Sarah Vaughan. Clifford Brown died in a car crash in 1956 on the Pennsylvania Turnpike.

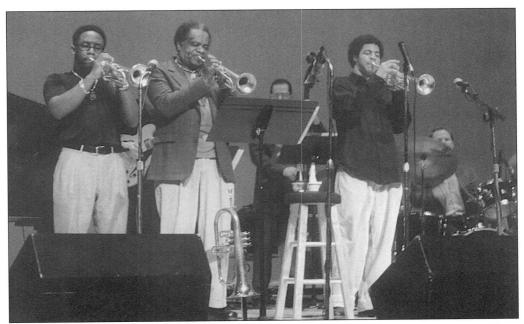

Jazz great Donald Byrd has mentored many young artists during his teaching career, from Herbie Hancock to the members of the Black Byrds. Byrd continues to tour around the world and mentors students at Delaware State. During this 1999 concert he highlighted two of his protégés. Pictured from left to right are James Gibbs (student), Donald Byrd, and Christopher Lowery (student).

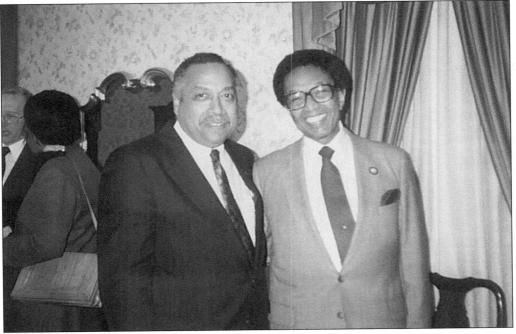

The jazz tradition will continue on with the awarding of an honorary doctorate degree in 1998 to the "Ambassador of Jazz" Billy Taylor, shown here with President William B. DeLauder.

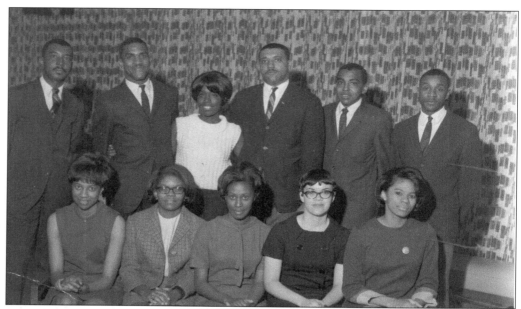

In recent years, more students have entered into the business department, where they have excelled and gone on to work in major corporations such as Mobile Oil. The honor society for business majors is Phi Beta Lambda. The top photograph shows members of Phi Beta Lambda in 1966–67. The bottom photograph shows the 1979 Career Fair sponsored by Phi Beta Lambda.

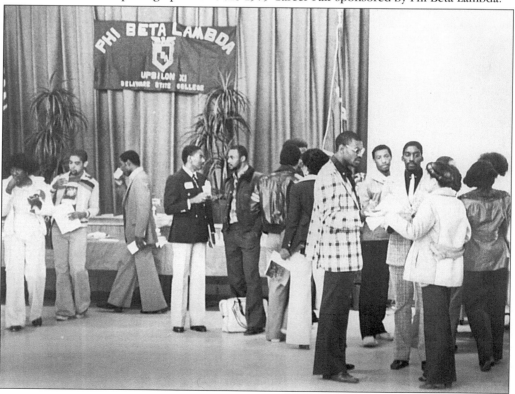

This photograph shows former officers of Phi Beta Lambda. Pictured, from left to right, are Penny Crump, Celestine Hammond, Peggy Cuffy, Brenda Dillard, Candi ?, and Mark Purnell. Mark Purnell and Brenda Dillard (Class of 1980) later married and now inspire others to financial success through their tape entitled "Committed to Serve."

In the 1966–67 academic year, these students formed a psychology club.

Delaware State students have been publishing a yearbook since 1947. Shown here is the *Statesman* staff in the 1966–67 academic year.

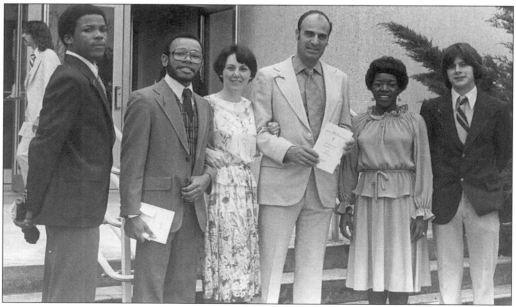

These students were inducted into the Alpha Chapter of Alpha Chi National Scholastic Honor Society on April 1, 1979.

Delaware State has increasingly attracted international faculty over the years. One of the outstanding international faculty was Dr. Vincent Damuah in the history department. Dr. Damuah left Delaware State in the early 1980s to form a new church in Ghana. He calls it the Afrikania Church rooted in Roman Catholicism and African nationalism. In 1982, following a coup in Ghana, Dr. Damuah became a member of the governing council, the PNDC (Provisional National Defense Council), under J.J. Rawlings.

In a similar fashion, more international students come to Delaware State, and in 1982, they formed the first International Students Organization. Some students have chosen to become citizens of the United States. These students are studying for their Immigration and Naturalization citizenship test administered at Delaware State.

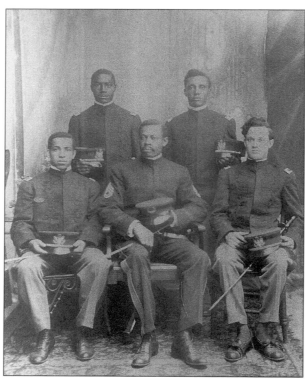

Like other land grant colleges, Delaware State required students to serve as military cadets and to drill in order to build a loyal officer corps made up of citizen soldiers. These cadets posed for this photograph in 1910. Seen from left to right are C.C. Showell, Clarence Woodland, Major Officer Charles Gaillard, Alfred Casper, and ? Drain.

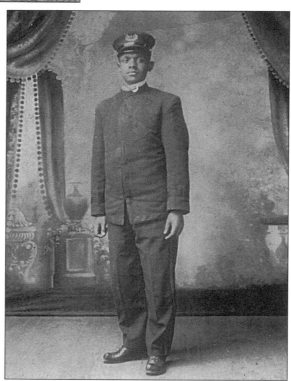

Cadet Harry Blockson is shown here posing in his cadet uniform, c. 1910.

African Americans served gallantly in World War I. They served in segregated units divided into the 92nd and 93rd Divisions of the United States Army. The latter served under French command. Like other African Americans, Davis Shockley, Class of 1911, served in World War I. He is shown here in uniform in 1919.

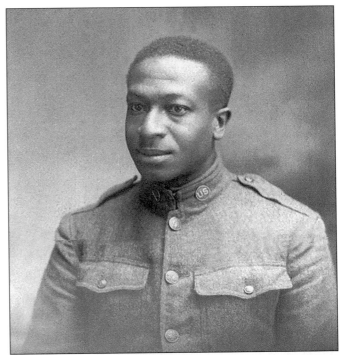

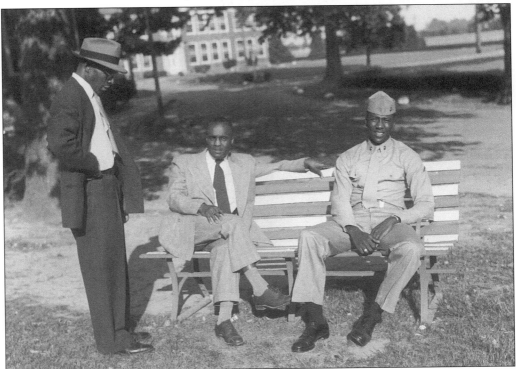

African Americans were once again called to duty in World War II and in the Korean War. Here a returning veteran sits on a bench in front of Delaware Hall, *c.* 1950s.

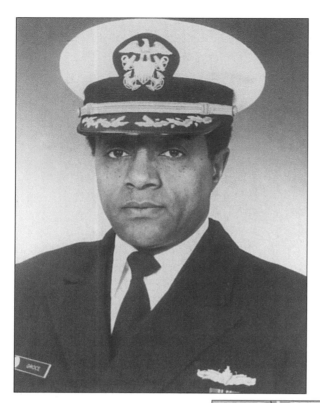

Continuing the military tradition, Capt. Thomas C. Groce graduated from Delaware State in 1956 and entered the U.S. Navy. He served 25 years and earned a doctorate degree in higher education.

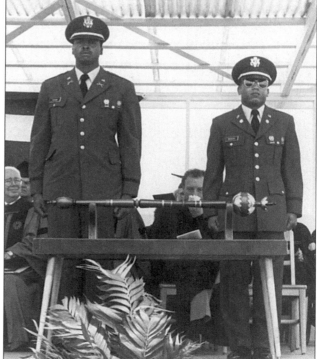

In recent years, Delaware State revived its ROTC program and has seen several graduates commissioned as officers, including Alfred Parham (left) and Stewart Wiggins (right). Both men were commissioned as officers in the U.S. Army on May 20, 1984.

In May 1987, Dr. Daniel Coons hosted the Black Wings Reception at Delaware State as a part of the inauguration of the new Airway Sciences Program. This marked the revival of a tradition dating back to 1939, when Delaware State began offering classes in pilot training at Dover Municipal Air Field. The federal government named five historically black universities and colleges to train pilots through the Civilian Pilot Training Act. The other four schools were Howard University, Hampton University, North Carolina A&T, and West Virginia State College. Later, Tuskegee was added to the list. Several pilots who received training through the Civilian Pilot Training Program went on to train as Army Air Corps pilots at Tuskegee. During World War II, these African-American pilots were known as the Tuskegee Airmen.

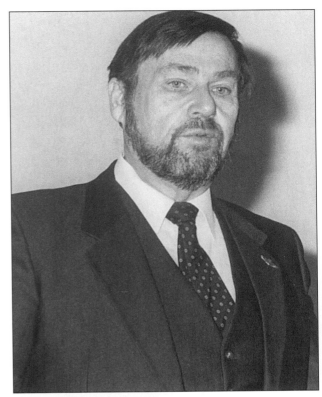

Dr. William G. Dix, president of the Delaware State Board of Trustees, is seen speaking at the Black Wings Reception in 1987. African-American Army Air Corps pilots were also known as the Black Wings.

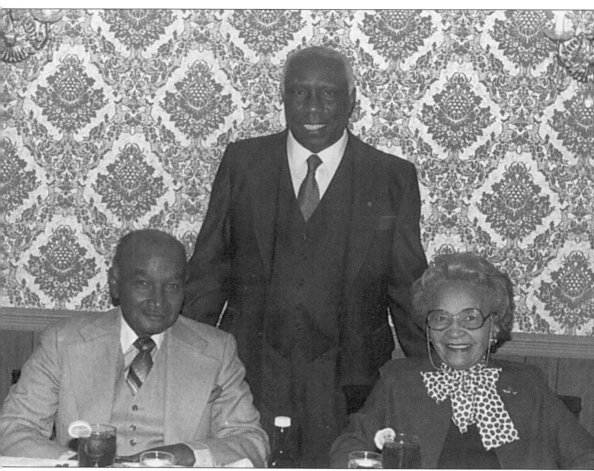

There have been several stellar faculty members at Delaware State over the years that have reached icon status. This photograph shows the 1982 retirement luncheon for Dr. W.R. Wynder, who was the first graduate from Delaware State to earn a doctorate degree. He later returned to Delaware State and served as vice president for academic affairs. Wynder Towers, a dormitory on campus, was named after him. Seen from left to right are W.R. Wynder, Luna I. Mishoe (president of Delaware State), and Mrs. Wynder.

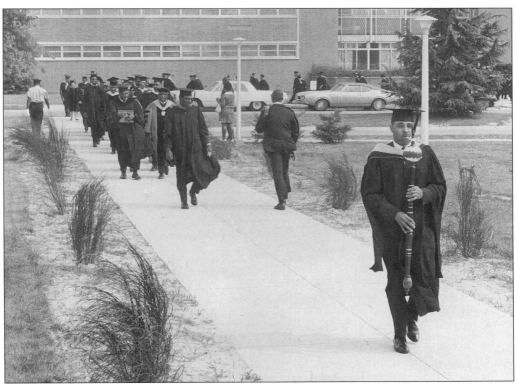

Professor Ulysses Washington set the standard for excellence in agriculture at Delaware State, and has held the honor of carrying the mace at graduation for several years. The agriculture extension building was named in his honor.

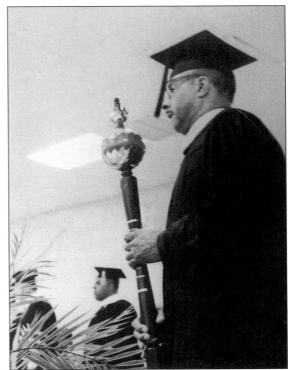

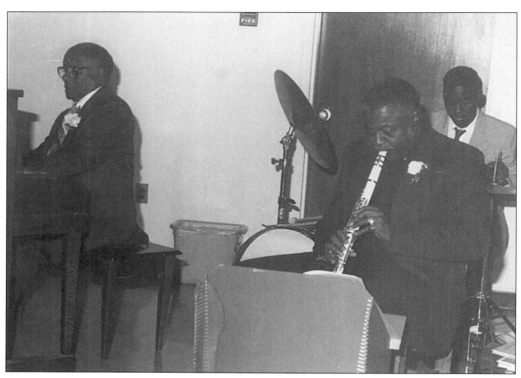

Delaware State has enjoyed the excellence of a dedicated faculty that is committed to teaching, research, and service as these music faculty are demonstrating at a reception. Pictured from left to right are Dr. Howard Brockington, Mr. Milton Cooper, and unidentified.

In addition to a stellar faculty, Delaware State has been blessed with top-notch administrators and members of the board of trustees. The photograph at left shows Dr. Gladys D.W. Motley, vice president of student affairs (left), and Ms. Winifred C. Harris, executive assistant to the president (right), in 1983.

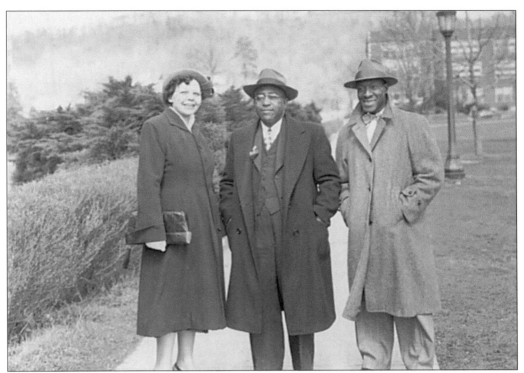

Academic dean ? Finney (far right) is shown here visiting West Virginia State College in 1951.

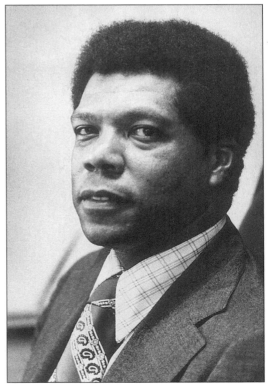

Pictured here is Academic Dean Theophilus E. McKinney Jr.

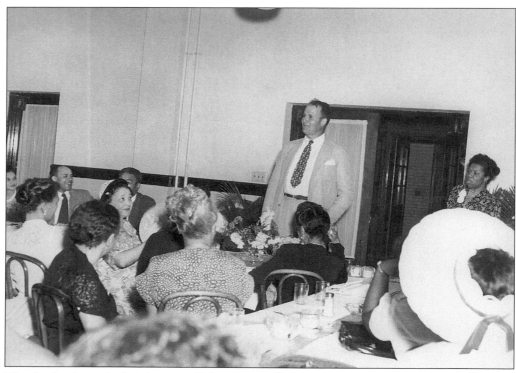

Like the faculty and administrators, Delaware State has been blessed with exceptional members of the board of trustees and political leaders. The top photograph shows Governor Elbert N. Carvel (standing) speaking to President Chapman and the faculty, *c.* 1950. Board of Trustees President Walton Simpson (left) and Governor Russell Peterson (right), *c.* mid-1970s, are shown below. President Luna I. Mishoe is behind them.

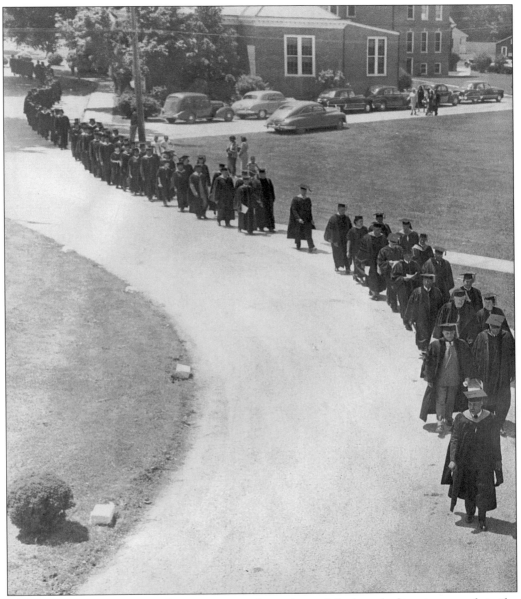

Students, esteemed faculty, administrators, and members of the board of trustees march to the graduation ceremonies in the late 1940s.

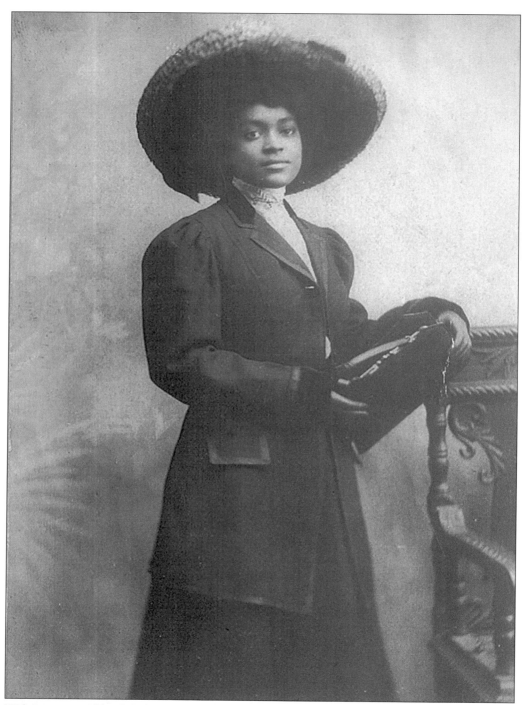

With instructors like Cecie P. Henry, students were motivated to achieve academic success and graduate from Delaware State. Thanks to teachers like Ms. Henry, graduates throughout the 20th century were inspired to contribute to the building of a nation. The elegance and grace of Ms. Henry fills this photograph, taken in 1901.

Four
STUDENTS AND ALUMNI

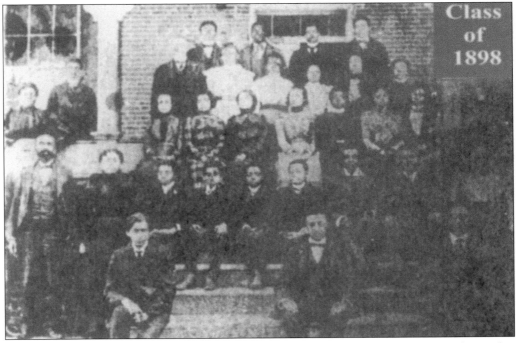

The first class to graduate from Delaware State was in 1898. The first graduates were John Boykin and Howard Day Young.

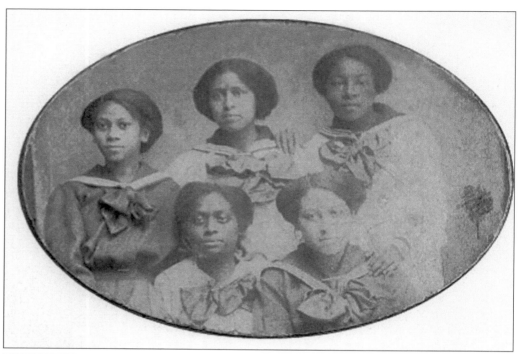

In 1897, Delaware State admitted its first women as boarding students and hired a matron to supervise them. Land grant colleges were the first institutions of higher learning to become coeducational. The lovely women who posed for this *c.* 1910 photograph are, from left to right, Althea Mitchell, Virginia Campbell, Edna Selby, Ethel Friend, and unidentified.

John H. Horner Sr. was a member of the Class of 1908.

Two Delaware State students are shown here reading. In 1902, the Presiding Elder of the Dover District Delaware Conference of the Methodist Episcopal Church reported, "legislative enactments . . . [aimed to] disfranchise Negro voters, fixed as a qualified basis, education. . . . these agitations [have] put gray heads and dimmed eyes to work in primers." The literacy test was a requirement to vote in Delaware.

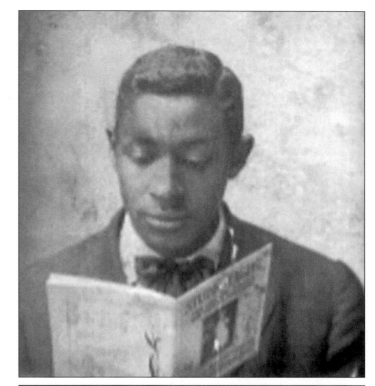

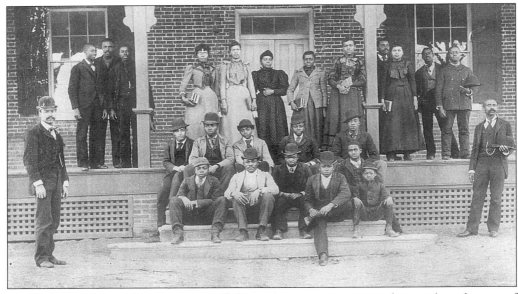

These students, pictured at the turn of the 20th century, pose on the porch and steps of Loockerman Hall.

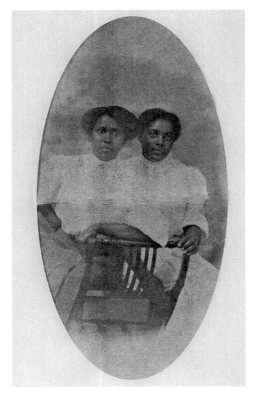

Delaware State offered a rare opportunity for women to obtain degrees in higher education. Virginia Campbell and Emma Williams took this opportunity to study at Delaware State at the turn of the 20th century.

Effie Prettyman shows serious contemplation in this undated photograph.

This unidentified student at Delaware State is a picture of simple elegance.

Mary Dobson is shown posing for her class photograph around 1910.

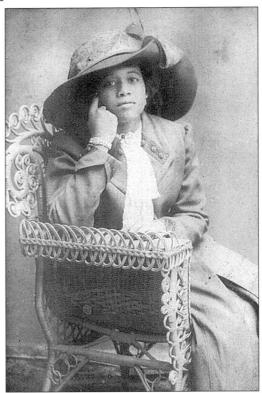

Vitaline Collins gave this photograph to classmate C.C. Showell, Class of 1911. C.C. Showell was also a cadet.

Major Officer Charles Gaillard is shown here out of his cadet uniform, wearing the latest in men's fashion wear, around 1910.

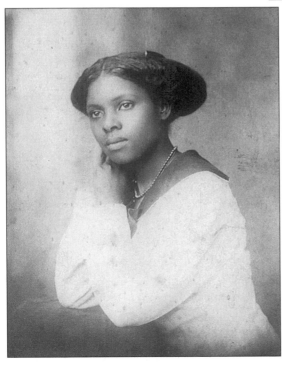

This pretty young student is Marie Wainwright.

This unidentified young student was probably attending the preparatory school when this photograph was taken. The young girl may have been the daughter of William C. Jason, president of Delaware State.

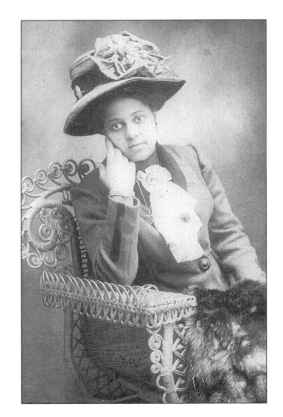

This young student at Delaware State is a picture of elegance with fine attire, including a fur wrap.

Delaware State student George Barns is pictured here; he went on to become Dr. George Barns, possibly serving as a physician. In 1912, most graduates from Delaware State went on to teach. Others entered a variety of professions and trades.

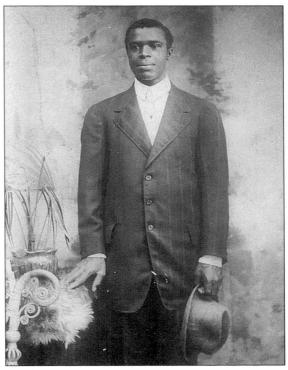

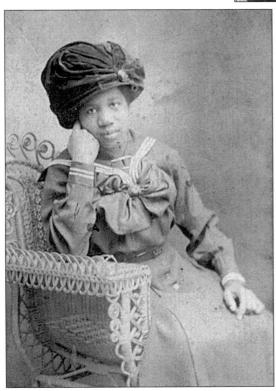

Taken in 1910, this photograph shows Mary Harris Smith, Class of 1913.

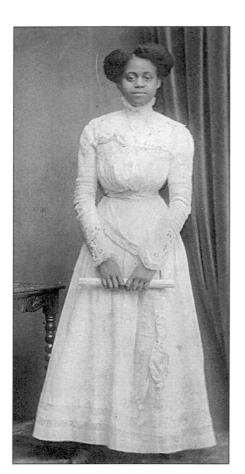

This elegant young woman in her fine graduation dress was Blanch Tribbit. She is shown here holding her diploma.

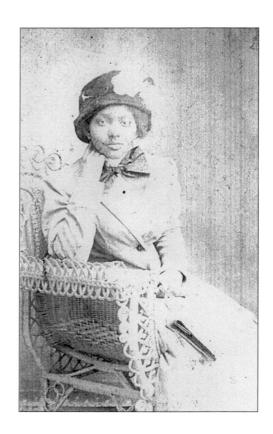

Lottie Webb was another member of the Class of 1913.

96

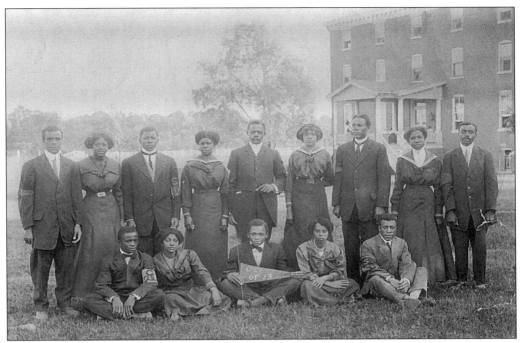

The Class of 1913 poses in front of Lore Hall.

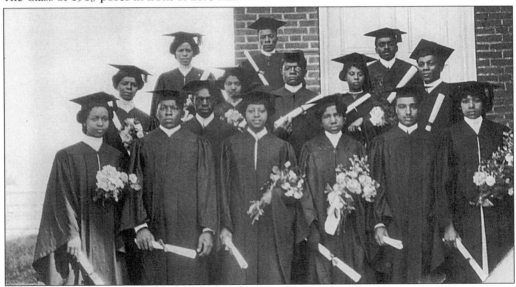

Graduation in the early days of Delaware State was held on the porch of Loockerman Hall, with the audience seated in front under the protection of trees and a tent. The graduating class of 1913 is shown here on the steps of the chapel (Thomasson Hall) on commencement day. Pictured, from left to right, are as follows: (front row) Susan M. Jason, Ellis A. Blockson, Ethel Friend, Mary Hester Harris, Harold Dickerson, and Vitaline Collins; (middle row) Cordelia Townsend, unidentified, Lottie Webb, T.O.T. Laws, Katie Barclay, and Charles Purnell; (back row) Irene Strickland, George Anderson, and unidentified. George A. Barnes was missing from the photograph. Susan M. Jason later married Ellis A. Blockson.

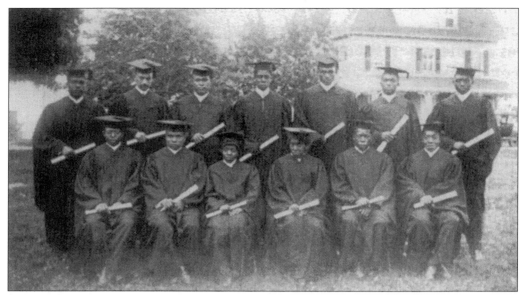

The Class of 1914 is shown on the eve of the outbreak of the Great War in Europe.

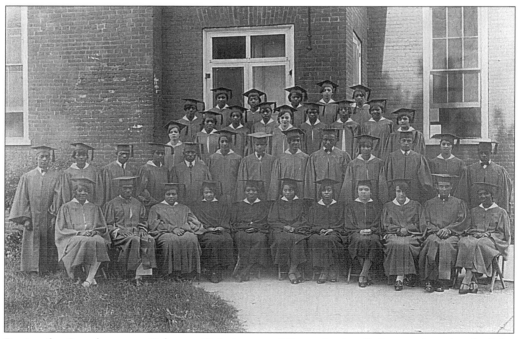

During the Grossley years, Delaware State improved its academic offerings and modernized the campus. Grossley also attracted faculty members with advanced graduate degrees. This in turn attracted more students to the school. Shown in this photograph is the Class of 1927 on graduation day.

These happy young ladies are enjoying a bright sunny day in front of Jason Hall in 1930. From left to right are the following: (front row) Ola Postle, Eva Hicks, Claretta Slater, Beulah Harman, and Claudie Stevenson; (back row) Sara Dickerson, Marie Curry, and Martha Evans.

In 1932, Delaware State expanded its collegiate offerings to include a four-year degree program with bachelor's degrees in arts and sciences, elementary education, home economics, agriculture, and industrial arts. In 1934, the first students graduated with bachelor degrees. Pictured from left to right are Daniel Thorpe, Rachel Warren, Ruth Williams, Vivian Hughes, and George W. Evans Sr.

Delaware State included a high school division among the other academic divisions. There were only two high schools in the state for African Americans, with one on the Delaware State campus. Shown here is George W. Evans receiving considerable attention from these two lovely ladies. Evans was among the first to earn a bachelor's degree in 1934. He also attended the preparatory school at Delaware State. Lillian Rochester is pictured on the left and Viola Waples is on the right.

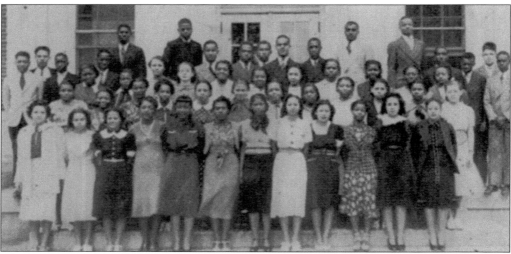

In 1939, Delaware State graduated the largest high school class to that date. By 1952, the high school department had been abolished and was replaced by William Henry High School in Dover. The Class of 1939 includes Agnes Allen, Eva Baynard, Ellene Bradshaw, Hilda Boyer, Ellen Burbage, Mary F. Burton, Corinne Carey, Henrietta Carney, Fred Cephas, Winifred Clarke, Hallie Coleman, Lula Cooper, Gertrude Cottman, Nelson Crockett, Rudolph Dale, Blanche Fountain, Violet Games, Gladys Gibbs, Charles Gowens, Althea Greene, Nila Griffith, Charles Guy, Gladys Guy, Alton Harmon, Lillian Harmon, Bernice Harris, Catherine Hayes, Elizabeth Holland, Eunice Hopkins, Dorothy Johns, Alfred Johnson, Mary Johnson, Harold Lingo, Grace Lloyd, Grace Lloyd, Alice Mitchell, Doris Morgan, James Neal, Leila Nichols, Elwood Norwood, Pauline Oney, Martha Parker, Warren Pritchett, Grace Scott, Paul Selby, Roberta Seagers, Alonzo Shockley, Elizabeth Shockley, John Smith, Mildred Smith, Louise Stanley, Ada Stewart, Ethelda Street, Norman Travis, Lindord Ward, Francis Waters, Edith Watson, Noah Webb, and Florence Wilson.

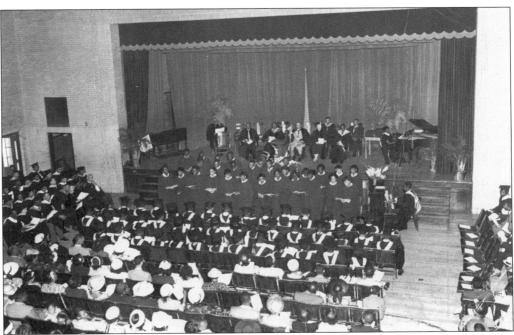

Most commencement ceremonies are held outside at Delaware State, but on occasion, inclement weather requires the ceremonies to be held inside. This graduation was held indoors at the Booker T. Washington School Auditorium in Dover.

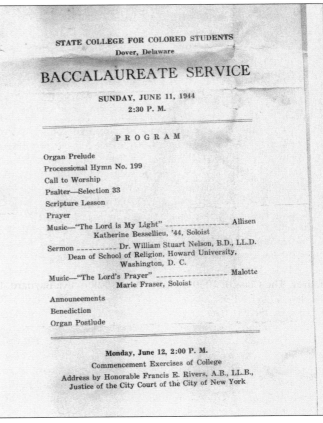

STATE COLLEGE FOR COLORED STUDENTS
Dover, Delaware

BACCALAUREATE SERVICE

SUNDAY, JUNE 11, 1944
2:30 P. M.

PROGRAM

Organ Prelude
Processional Hymn No. 199
Call to Worship
Psalter—Selection 33
Scripture Lesson
Prayer
Music—"The Lord is My Light" ---------------- Allisen
Katherine Bessellieu, '44, Soloist
Sermon ---------- Dr. William Stuart Nelson, B.D., LL.D.
Dean of School of Religion, Howard University,
Washington, D. C.
Music—"The Lord's Prayer" ------------------ Malotte
Marie Fraser, Soloist

Announcements
Benediction
Organ Postlude

Monday, June 12, 2:00 P. M.
Commencement Exercises of College
Address by Honorable Francis E. Rivers, A.B., LL.B.,
Justice of the City Court of the City of New York

Pictured is a graduation program from 1944.

DR. M. E. THOMASSON
Director of the Division of Arts and Sciences

Message to the Graduating Class: Commencement season brings two different feelings to the perceptive college worker. First, there is a feeling of regret that those whom one has seen daily for four long years would suddenly scatter and pass out of view. There is, also, the feeling of elation that those who have worked for four long years for the triumphs of Commencement Day should at last have reached their goal.

Of the two, the feeling of elation is the stronger. Youth strains at the leash. "We have spent four long years in preparation to commence life's triumphant journey. Now we are ready. Let us go free." It is right that you should go.

As one who has watched each of you gain in steadiness and fitness, and grow in the sense of responsibility for the groups of which you are parts, I see you go with satisfaction, confident that you will contribute substantially to the betterment of the society in which you will serve.

FACULTY RESEARCH

During the 1954-1955 school year, various members of the faculty of

GRADUATE CHAPTER OF DELTA SIGMA THETA SORORITY COMES TO DELAWARE STATE COLLEGE

On April 28, 1955, the Epsilon Kappa Sigma Chapter of Delta Sigma Theta Sorority was established on the Delaware State College Campus by the Eastern Regional Director, Soror Jennie B. Taylor, Gamma Kappa Sigma Chapter, Tarboro, North Carolina.

Chapter members are: Soror Helen Washington, President; Soror Martha Woodfolk, Vice-President; Soror Maye Grant, Recording Secretary; Soror Helen Games, Treasurer; Soror Annetta Henry, Sergeant-of-Arms; Soror Bernice Taylor, Chaplain; Soror Judith White, Historian; Soror Dorothy Talbot, Journalist; and Soror Phyllis Parson. Other charter members, Neophyte Virginia Dennis and Neophyte Minnie Wynder, were initiated.

Other sorors present were: Allie M. Holly, President of Gamma Omega Sigma Chapter, Wilmington, Delaware; Ruth Laws, Gamma Omega Sigma Chapter; Gertrude Barnes, President of Xi Sigma Chapter, Philadelphia, Pennsylvania; and Madeline Johnson, unaffiliated.

Dr. Jerome H Holland, President of Delaware State College, gave a warm welcome to the chapter. After the ceremonies the sorors were serenaded by the Psi Epsilon Chapter of Omega Psi Phi Fraternity.

AKA SORORITY INSTALLED AT D. S. C.

At last, the young women of Delaware State College have received what they have so long desired, a sorority. Sororities and fraternities are two of the most outstanding extra-curricular activities at many colleges. The main objectives of these two organizations is to help to promote better womanhood and manhood. Sororities and fraternities are not only beneficial while one is in college but also after one leaves college.

FACULTY ROUND TABLE STUDY GROUP PRESENTS DR. TANNER G. DUCKREY

Dr. Tanner G. Duckery, Superintendent, District Two; School District of Philadelphia, Philadelphia, Pennsylvania, addressed the entire D.S.C. College Family on Tuesday, May 10, 1955 under the auspices of the Faculty Round Table Study Group of Delaware State College, Dr. Duckrey, who is one of the most outstanding educators in the nation, spoke on the subject " What Works in the Field of Intergroup Relations", Earlier in the afternoon Dr. Duckrey addressed the College Faculty and Staff on the subject "Integration in the Philadelphia Schools." In both of his lectures the learned speaker covered well vital areas of human relations.

This was the fifth and final lecture of a series that occured during the 1954-55 school year. Chairman of the Faculty Round Table Study Group is Dr. Harold Weaver, Head of the Department of Elementary Education at Delaware State College.

REV. EDWIN ELLIS OF LINCOLN UNIVERSITY SPEAKS TO D. S. C. STUDENTS

Rev. Edwin Ellis, a senior in the Theological Seminary at Lincoln University and President of the Student Seminarian Organization, brought a word of encouragement to the students of Delaware State College during Chapel Service on Tuesday, May 17, 1955.

Recently, he was one of five students of Lincoln University elected to "Who's Who Among Students in American Universities and Colleges." This election was made on the basis of excellence, and sincerity in scholarship, leadership and participation in extracurricular and academic activities, citizenship to the school, and promise of future usefulness to business and society.

CLASS OF 1955 OBITUARY
By
Eleanor O'Neil - Ethel L. Belton

Deceased — Died Of:

Beatrice Brewster
 Commuting
John Bundy
 Delaying a dramatic scene
Daniel Fisher
 Party time
Rick Giles
 Chemistrism
John Gilmore
 Guitarism
William Goodall
 Beating drums
Loretta Gross
 Stitching her wedding dress
Roland Holmes
 Working on a juvenile delinquent case
Emmett Jeter
 Bragging
Herbert Leonard
 Slinging the mop in the dining hall
Joseph Marshall
 Being too friendly
Thelma Mason
 In silence
Theresa Nicholson
 Trying to sing high "C"
William Oliver
 Trying to imitate Roy Hamilton
James Parker
 Trying to be an athlete
James Price
 Making A's
Mary Scott
 Trying to be sufficient
Doris Swiggett
 Infection from Miscroscopic organism
Eddie Waples
 Trying to figure out mathematics and Ethel Belton
Anita Watson
 Rushing to school
Richard Wright
 Keeping grass alive on the campus

CAMPUS CHATTER

1. Girls, follow in Bertha Turner's footsteps, Bill Morris is her one and only.

2. What happened? Eleanor O'-Neal, has that Air Force fellow taken up all your time? (Gus is still on the scene).

3. Hi! Nick Coles, you seem to be "handling it" pretty nice. Keep up

FACTS, NOT FICTIO
By Ethel Louise Belte

A woman who is smart en ask a man's advice seldom is enough to take it.

Maybe they call it take-ho because there is no other pl can afford to go with it.

When you are getting from the rear, it means you front.

A problem well stated is lem half solved.

The only way a man can better of a woman in an ar is to let her keep on talkin she has won it.

Wine increases the enjoya food and conversation. Too of us drink, not for enjoyme to lose ourselves.

We are childlike. We do nothing. We know how to do but we don't always know wh

How many things come in Stockings, shoes, gloves, bra

Experience is a hard teache gives the test first and the afterward.

Only one-tenth of the land area is adequately mapp

Spring is here. How do I A little virus told me so.

The longest odds in the wor those against getting even.

It takes a mighty conscie man to tell whether he's tir just lazy.

In marriage like boxing, the liminaries are often more ente ing than the main event.

In 1948 a group of Delaware State students, including Homer Minus, who is affiliated with the university today, sued the University of Delaware for admission. They won their battle against segregation by gaining admittance to the University of Delaware. Soon after, Ethel Belton sued the state of Delaware for admittance into the all-white Claymont High School in northern Delaware. She won her suit after the state challenged the lower court's decision in Delaware by taking it to the U.S. Supreme Court. Ethel Belton's challenge to segregation was included in the landmark case *Brown v. Board of Education, Topeka, Kansas, 1954*. Here, Ethel Belton is pictured above her column in the student newspaper, *The Hornet*. She is pictured on the far right. Classmate Eddie Waples was reported as "trying to figure out mathematics and Ethel Belton."

Pictured above is the court case document argued in front of the Supreme Court of Delaware in 1952. The state lost the two cases titled *Gebhart v. Belton* and *Gebhart v. Bulah* and appealed to the U.S. Supreme Court with Earl Warren serving as the Chief Justice. The two attorneys representing Belton and Bulah were Jack Greenberg and L.L. Redding from the Legal Defense Fund of the NAACP. (Courtesy of Kenneth Clark Papers, Library of Congress.)

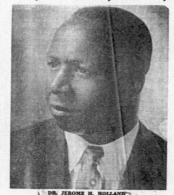

THE HORNET

"THE STINGING TRUTH"
(SENIOR PICTURES INSIDE)

VOL. XII, No. IV DELAWARE STATE COLLEGE, DOVER, DELAWARE MAY 27, 1956

Commencement Address To Be Delivered By Urban League's Dr. Granger

Dr. Gray of Philadelphia to Speak at Baccalaureate

Dr. William Herbert Gray, Jr., Pastor of Bright Hope Baptist Church, Philadelphia, Pa., will speak at the Baccalaureate Service at Delaware State College on May 27, 1956. The program will be held in Delaware Hall and will begin at 3:30 p.m.

Born in Richmond, Va., the son of Rev. William H. and Mary Smith Gray, Dr. Gray was ordained into the ministry in 1943. Yet, a look at his extensive education will readily show that he is not confined to ministerial duties alone. Our speaker received a B. S. degree in 1933 from Bluefield State College, Bluefield, West Virginia; M. S. from the University of Pennsylvania, Philadelphia, Pa; Ph. D. from the same institution in 1942; and a D. D. (Honorary) degree from Edward Waters College in Jacksonville, Florida, in 1952.

Dr. Gray's professional experience is indicative of his preparedness. From 1934-1941 he was Professor of Education and Principal of Demonstration Schools and also Field Director of Extension at Southern University, Baton Rouge, La. In 1941, he became President of Florida Normal and Industrial College at Saint Augustine, Florida. Dr. Gray served in this capacity until 1944 when he then became President of Florida Agriculture and Mechanical College at Tallahassee, Florida. This able person was in 1949 called to be the Pastor of Bright Hope Baptist Church in Philadelphia, Pa., a position which he still holds today. The position of Editor, Philadelphia's pro-American newspaper was

DR. JEROME H. HOLLAND
President, Delaware State College

CLOSING OF SCHOOL YEAR

With the closing of the 1955-56 school year, Delaware State College ends a very important phase in its progressive developments. The three year period starting with the 1953-54 school year has been marked by unusual educational achievements. This success is the result of the combined efforts on the part of the Faculty,

DELAWARE STATE COLLEGE
Dover, Delaware
Office of the Dean-Registrar
May 28, 1956

To the Members of the Class of 1956:

Today is a most happy day for you and for your Alma Mater. I would like to call your attention to the fact that your Alma Mater's investment in you and the sacrifices of your parents and relatives are expressions of confidence in your future. With ambition, courage, and perseverance, you will, I am sure, continue to justify the confidence that has been placed in you.

I know that I speak for the entire Delaware State College family in congratulating you upon your graduation and in extending to you our best wishes for a full measure of success and happiness in the years to come.

Very sincerely yours,
W. A. Daniel
Dean-Registrar

dent body is revealed by the employment opportunities being offered the members of the class of "56". This is the beginning of a new era for the graduates of Delaware State College.

The next three school years, perhaps show a more extensive development. The Basic educational foundation has been accomplished. The potentials are pres-

COMMENCEMENT

Dr. Lester Blackwell Granger, Executive Director of the National Urban League, will deliver the commencement address at Delaware State College on May 28, 1956. Commencement will be held in the auditorium of Delaware Hall at 2:00 p.m.

Dr. Granger, born in Newport News, Virginia, has served the American community for over 30 years, as both a professional and a volunteer worker in a variety of capacities.

He received an A. B. from Dartmouth College, did his graduate studies at New York University, his professional studies at New York School of Social Work, and received honorary Doctorates of Law and Humane Letters from Dartmouth College, Wilberforce University, Columbia University and other colleges.

Since 1941 he has been Executive Director of the National Urban League. Previously he served as teacher, local Urban League executive, youth counsellor, and director of legislative investigations. He has been advisor of state and federal agencies and an officer of national civic and professional social work associations.

His travels have carried him into all parts of this country and as far as Asia and the South Pacific. He served in World War I as Lieutenant of Field Artillery. In World War II he was a special advisor to the Secretary of the Navy, James Forrestal. His recommendations played a major part in the Navy's

Delaware State underwent desegregation beginning in 1952. Shown on the lower right side in this photograph, appearing in the student newspaper *The Hornet,* is the first white student to attend Delaware State. Garry DeYoung was a veteran of World War II and the Korean War. He won six bronze stars in the European Theatre of World War II.

Even with the excitement of the Civil Rights Movement and its direct impact on Delaware State, students continued to focus on their studies, as this senior was doing in 1966.

The calm did not last long—the turbulent sixties hit the campus in the spring of 1968 beginning with a student protest march on Legislative Hall in Dover. Students marched in support of social welfare programs in the state. Leroy Tate, president of the Student Government Association at Delaware State, organized the demonstrations. He is shown here standing next to the student holding the loudspeaker.

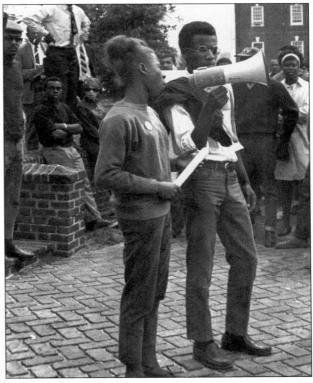

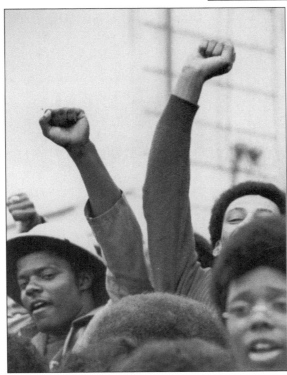

A demonstration broke out on the campus soon after the assassination of Martin Luther King Jr. in April 1968. Protests also broke out in Wilmington, DE, leading to the occupation of the city for 17 months by the Delaware National Guard.

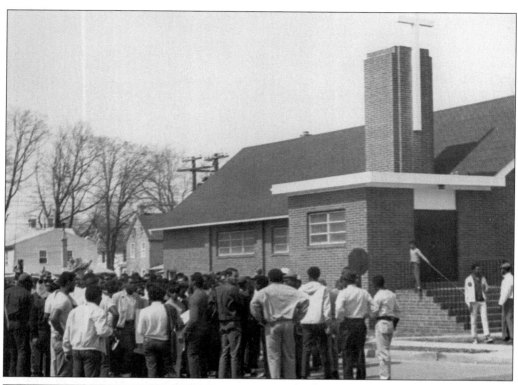

Students at Delaware State demonstrated while school and state officials were dedicating the new student center building, named in honor of Martin Luther King Jr. The students protested the presence of Governor Terry, who had ordered the National Guard to occupy Wilmington. They had other demands as well, such as the introduction of Black Studies into the curriculum, student evaluations of the faculty, abolishing the curfew for coeds, and the immediate dismissal of some administrators. Students are pictured here in front of the Mt. Zion AME Church in Dover.

Following the protest and shortly before the May graduation ceremonies, students organized "sleep-ins," occupying the new student center and Grossley Hall, the administration building. This led to the introduction of the state police and the National Guard on campus. President Mishoe then ordered the immediate closing of the campus.

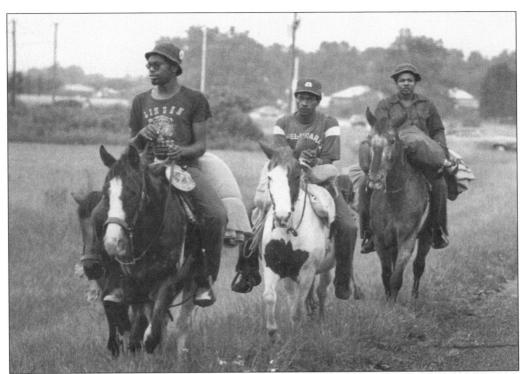

Life returned to a semblance of normality at Delaware State during the 1970s and 1980s. Here, three students are shown celebrating the nation's bicentennial in 1976. From left to right are Kennis Fairfax, Melvin Lawrence Jr., and Richard S. Lewis.

These students took advantage of a warm day during the 1980s by exercising outside.

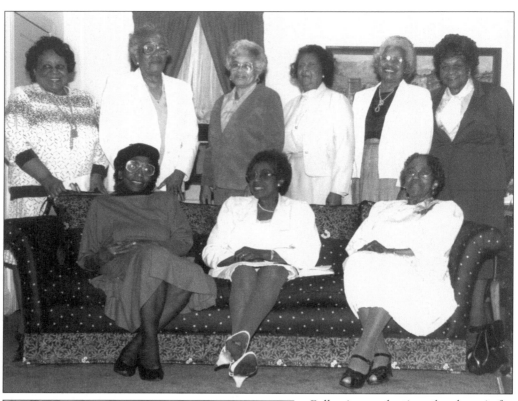

Following graduation, the alumni of Delaware State continue to maintain strong ties with the school. The Class of 1939 is shown here at their 50th anniversary celebration in July 1989.

These two lovely women were members of the Class of 1939.

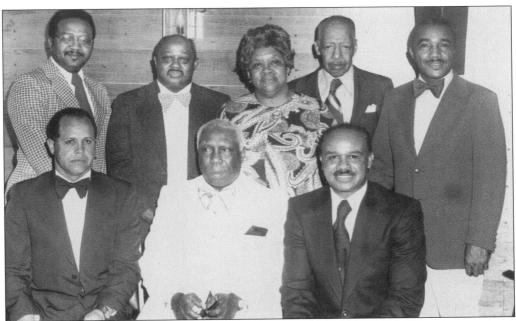

The first Alumni Association at Delaware State was founded in 1930. The alumni pictured met with President Luna I. Mishoe during the 1980s. From left to right are the following: (front row) Paul Grinnage, past DSC National Alumni president, Millsboro, DE; Dr. Luna I. Mishoe, president of Delaware State; and Felmon D. Motley, past DSC National Alumni president, Wilmington, DE; (back row) Harrison Short, past Sussex County Alumni Club president, Millsboro, DE; William Fountain, past Sussex County Alumni Club president, Milford, DE; Ms. Cora Warren, director of DSC Alumni Affairs, Dover, DE; Elton A. Downing, past Sussex County Alumni Club president, Milford, DE; and Denver B. Parker, past Sussex County Alumni Club president, Lewes, DE.

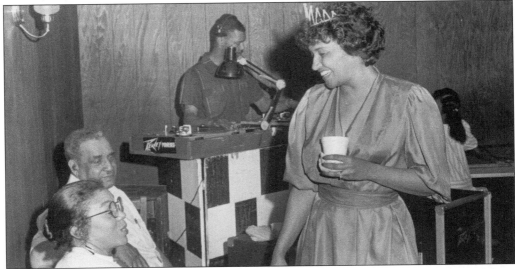

Each year alumni return and hold various celebrations including the crowing of Miss Alumni. Here, Mary S. Ward, Miss Alumni 1967, is pictured talking with the son and daughter of Charles C. Showell, Class of 1911. This photograph was taken in 1989.

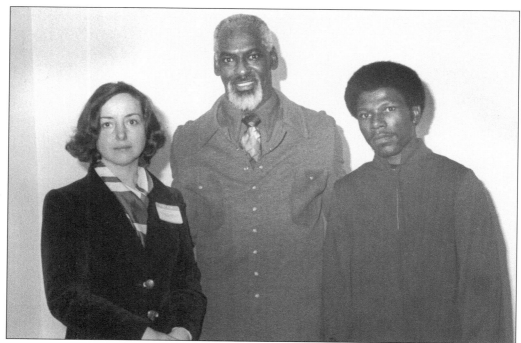

Robert Hunter, president of DSC Alumni Association, poses with two new members of the association. Pictured from left to right are an unidentified woman, Robert Hunter, and Andrew Hawkins.

Alumnus Yvonne Wise returned to Delaware State to perform at the alumni concert in May 1976.

Five
EXTRACURRICULAR LIFE

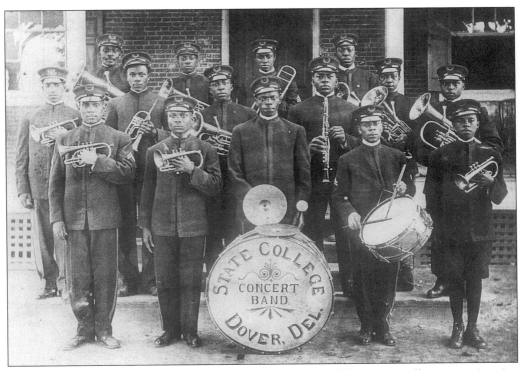

Extracurricular activities are essential to a healthy student life at any college or university. Concert and marching bands play an important part in the cultural life on campuses. In 1902, the first band at Delaware State was formed.

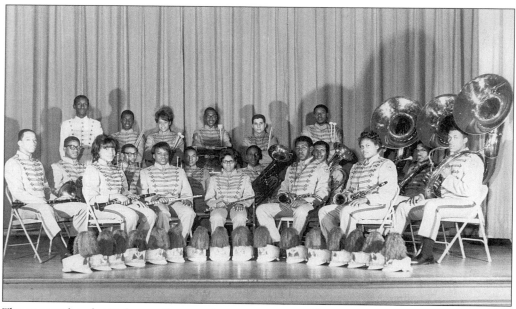

The concert band at Delaware State performs at a variety of functions in the state, the nation, and around the world.

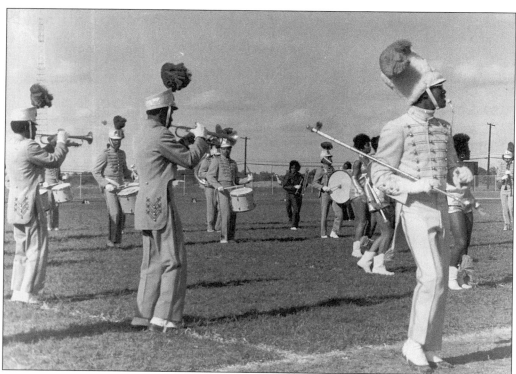

The Delaware State marching band performs at football half-time ceremonies. Marching bands at historically black colleges and universities are often the "main event" during football games. The drum major shown here is Tyrone Livingston, Class of 1971.

Sometimes the responsibility of performing can be a daunting task, as it appears to be for Rosalyn McNeal, Class of 1978.

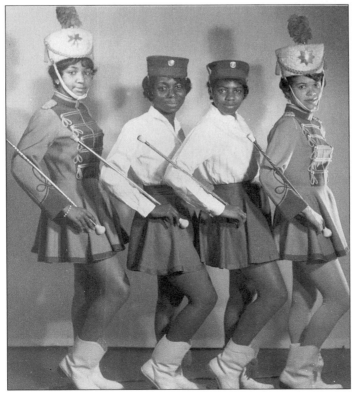

What would a marching band be without drum majorettes, like these snappy young women from Delaware State?

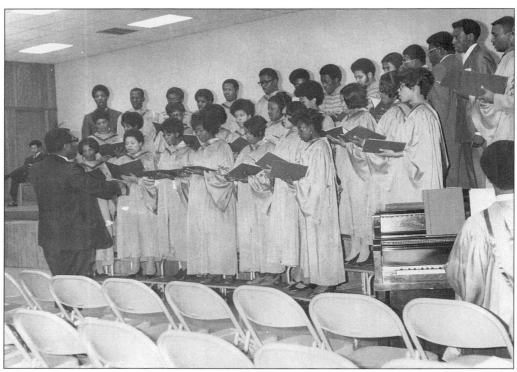

Along with the band, the Delaware State Gospel Choir plays an essential role in the cultural life on campus. President William C. Jason, like other contemporary black college presidents, toured the gospel choir as ambassadors for Delaware State.

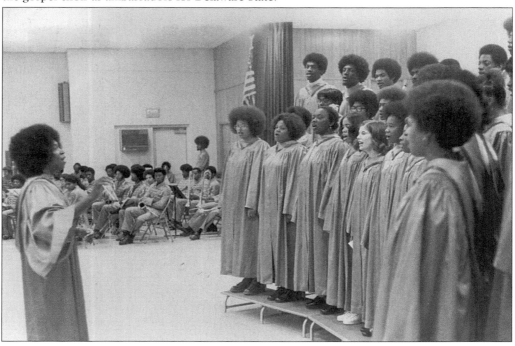

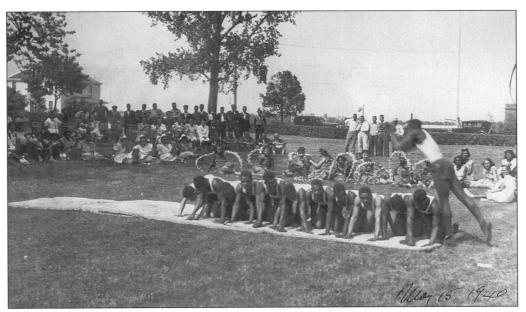

Delaware State students are performing gymnastics outdoors in May 1940

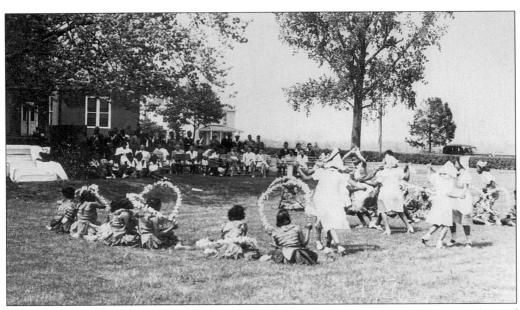

These young women are demonstrating their physical education skills for an audience in front of the former chapel/library (currently Thomasson Hall) on May 15, 1940.

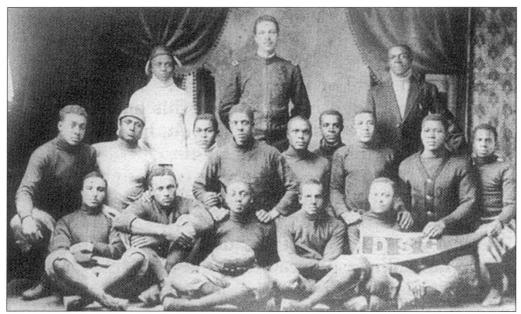

Physical fitness was as important as intellectual development at colleges and universities at the beginning of the 20th century. It was thought that an education was not complete without a physical education, and from this philosophy, competitive athletic programs sprang onto college and university campuses. The first football game played at Delaware State was in 1905.

Since its founding, Delaware State produced stellar football teams like the 1928 team pictured here. From left to right are as follows (first names not listed): (first row) Thorpe, Brinkley, Brown, Parker, Thomspon, Evans, and Davis; (second Row) West, Robinson, Whaley, Smith (captain), H. Sockum, Mason, and T. Sockum; (third Row) Coursey, Derrickson, Conway, Matthews, Morris, Caulk, Taylor, Jones, and Scott; (fourth row) Bailey (manager), Lewis (assistant coach), and Wood (coach).

Delaware State has produced many outstanding football players, such as Bryant "Gene" Lake, who was a Kodak All-America First Team selection and MEAC Offensive Player of the Year in 1984. During World War II, Felmon Motley teamed with Bennie George, Nathaniel Johnson, and William Stephens to form the "Army's Four Black Horsemen" at Fort Huachuca, AZ. Following the war, they played football together at Delaware State. Another football standout was Stephen "Catfish" Wright, who played defensive end in the mid-1950s and was considered the "heart and soul" of the team. Howard McKenzie was another outstanding football player at Delaware State and was named Most Valuable Player of the Hornets' 1957 CIAA championship squad. McKenzie served Delaware State after graduation as a coach, teacher, and administrator.

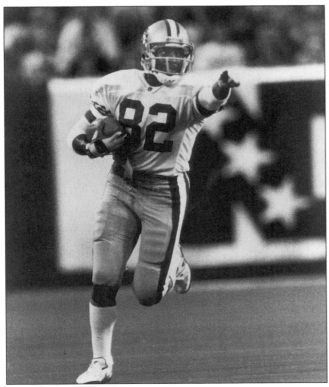

Probably the most outstanding football player produced by Delaware State was John Taylor, Class of 1985. Taylor is shown here in his San Francisco 49er football uniform. He caught the winning touchdown pass for the 49ers in Super Bowl XXIII on January 22, 1989.

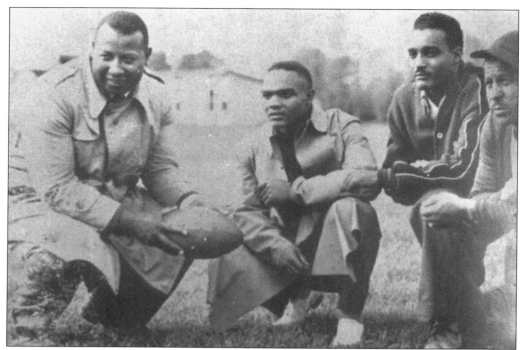

Along with talented players, Delaware State has had excellent coaching staffs over the years. The coaches seen here, from left to right, are Thomas (Tank) Conrad, head coach; "Nat" Johnson, assistant coach; Bennie "Catfish" George, assistant coach; and Leroy "Greenie" Easterly, assistant coach.

Bennie "Catfish" George retired from Delaware State in 1979. He assumed the helm of the basketball team as head coach in 1949 and held that position until 1971, becoming the most successful basketball coach in Delaware State history.

118

One of the most important events during college football season is Homecoming. For Delaware State, one of the highlights of Homecoming is the parade on Loockerman Street in downtown Dover, DE. The New York Metropolitan Chapter of the Delaware State Alumni Association proudly marched in the 1982 Homecoming Parade.

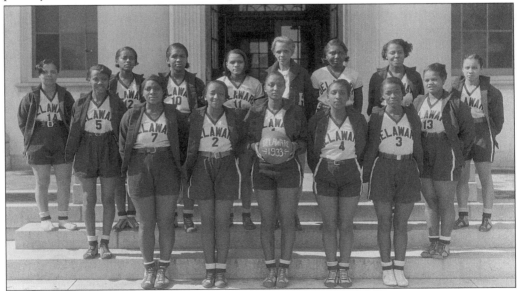

Women's sports also play an important role at Delaware State. The school launched its first women's basketball program in 1933. These members of the first women's basketball team are as follows, from left to right: (first row) Doris Grant, Lillian Rhodes, Lucille Brown (captain), Claretta Davis, and Frances Murray; (second row) Edna Walls, Priscilla Fountain, Gladys Corns, and Gladys C. Walls; (third row) Katherine Deshields, Rachel Warren (among the first five students to graduate with a bachelor's degree in 1934), Virginia Cornish, F.G. Brooks (coach), ? Mitchell, and ? Downing.

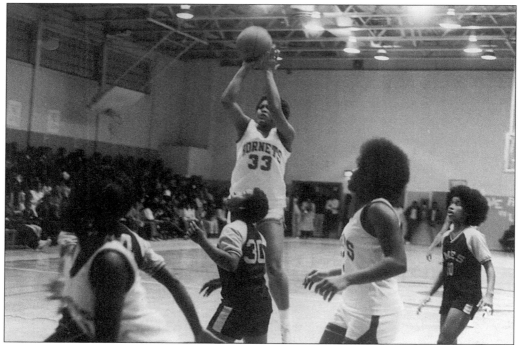

This photograph shows the Delaware State Women Hornets playing University of Maryland Eastern Shore in 1980. Delaware State adopted the name Hornets in the 1940s after their famous bus, which was known as "The Green Hornet."

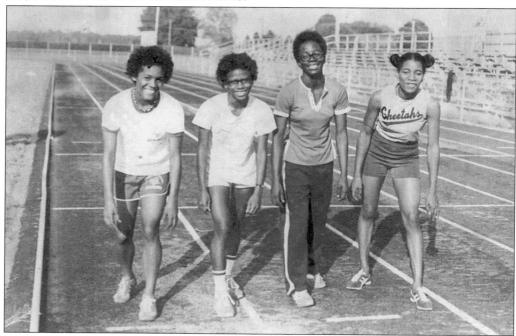

Women also run track at Delaware State. The runners pictured here are, from left to right, B. Wilson, D. Snaggs, J. Hebbs, and J. Samuels.

The first baseball team at Delaware State was organized in 1905.

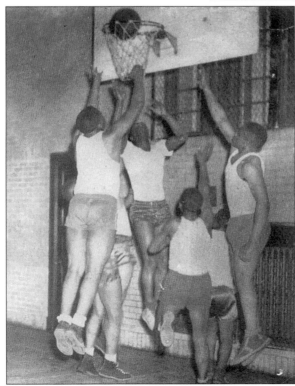

Delaware State began a basketball program in 1912. These young men are seen playing basketball in the 1940s.

Also in 1912, Delaware State added track to its athletic program.

Wrestling was eventually added to the school's growing athletic program. This Delaware State wrestler is shown competing in the 1985 Delaware State Invitational Tourney.

No athletic competition is complete without cheerleaders. Kim Davis is full of cheer, and builds school spirit in support of the basketball team.

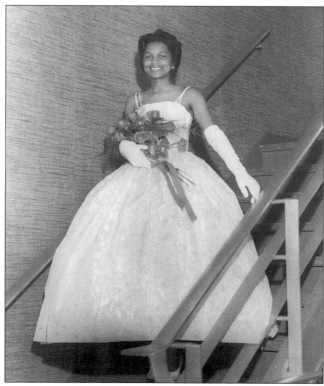

What school year is complete without a queen? In the 1963–64 academic year, M. Loretta Johnson was crowned Miss DSC.

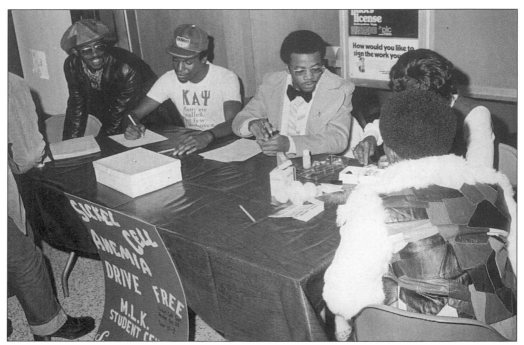

Equally important in college and university cultural life are greek organizations. The first fraternities established at Delaware State were Omega Psi Phi and Kappa Alpha Psi. They were chartered in 1947.

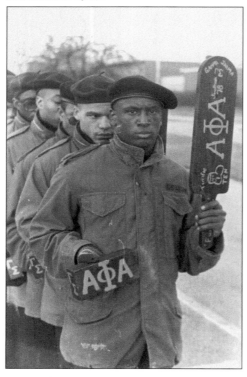

In 1948, Alpha Phi Alpha became the third fraternity to be established at Delaware State.

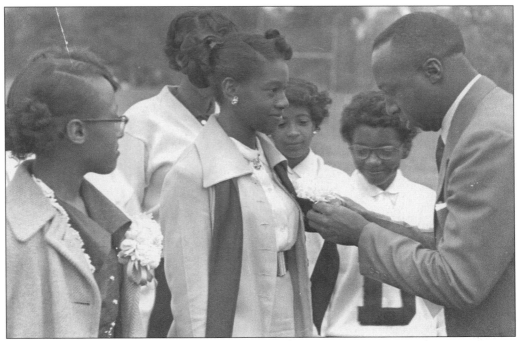

Alpha Kappa Alpha was the first sorority chartered at Delaware State in 1955. This was followed by the chartering of Delta Sigma Theta in 1958 and Zeta Phi Beta in 1960.

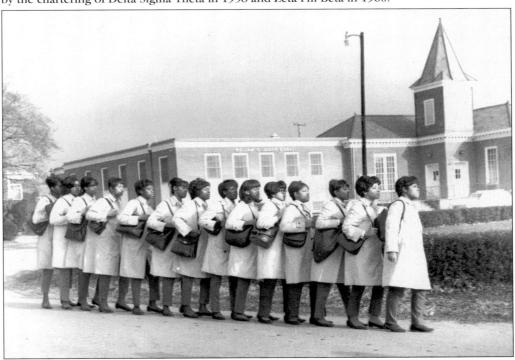

These serious young sorority women are in a pledge line marching in front of Thomasson Hall. This was a common scene on college and university campuses across the nation.

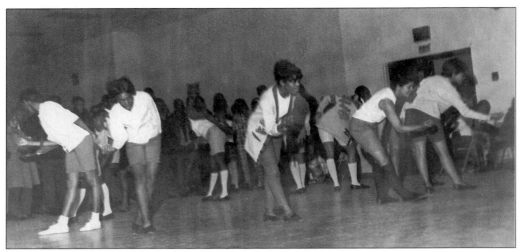

An important event for black sororities and fraternities is the Step Show. This is a unique feature of such organizations and allows members to maintain their history and traditions in the form of skits, dances, and music. Black fraternities and sororities hold competitions sometimes described as "stoppin' out with noise." Above is a step performance by Zeta Phi Beta Sorority, Inc., and below is one performed by Phi Beta Sigma Fraternity, Inc.

Alpha Kappa Alpha was the first Greek-letter organization established for African-American college women in America. It was formed in 1908 at Howard University in Washington, D.C. The sorority emphasizes that African-American women should better the socio-economic condition of others throughout the country. These young women are showing their committment by pledging Alpha Kappa Alpha Sorority at Delaware State in 1971.

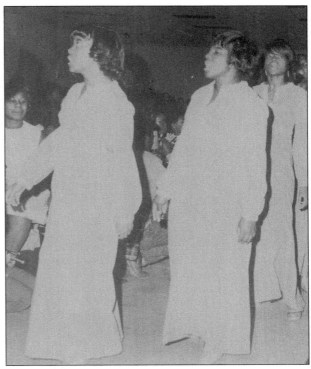

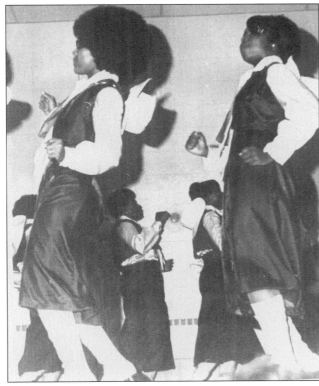

Entitled "Going into the Step Lean," this photograph, taken during "Hell Week" in 1972, shows Alpha Kappa Alpha pledges stepping.

The legacy of Delaware State is excellence and is attributed to the faculty, staff, and administration. Individuals such as Raymond Johnson (center) in music; and Richard Gilmore (right), business manager, made Delaware State a great institution of higher learning.

Above all else, students and alumni are a living tribute to the excellence of Delaware State University.